Sustainable Healthcare Reform:

Harnessing the Power of Capitalism to Fund our Social Needs

By

Steven Trobiani, M.D.

Table of Contents

Introduction

A Divisive Subject

On March 23, 2010 President Barak Obama signed into law The Patient Protection and Affordable Care Act providing health coverage for the uninsured while making sweeping changes to existing healthcare programs. If we were living in a democracy, this law would never have come to pass. Polls of American voters taken during the time in which the legislation was being debated showed overwhelming opposition to enactment of the legislation, with 85% opposed to passage of the bill.

We, however, do not live in a democracy. We live under a republic and, in a republic, our elected leaders are free to vote in accordance with their beliefs, and those beliefs may not necessarily reflect the will of the populace that they represent. Depending on the point of view taken, this may be viewed as either a strength or a weakness in our system. Whichever it is, our system of government does offer one recourse. If the actions of our representatives are sufficiently unpopular, those representatives can be replaced by popular vote at the next election. This did happen in the 2010 mid-term elections in which the Democratic Party lost more seats in Congress than any party had in 70 years.

The healthcare debate in the United States is not, however, about the country's political process. Though congressional approval ratings are in the single digits and at an all time low, the population's disapproval is misdirected. As a republic, our political process is healthy as demonstrated by the 2010 mid-term elections. We can and do change the choices our political leaders make when those choices are not

consistent with our wishes. Candidates and political pundits need not talk about changing our political process; that process is sound. The healthcare debate, instead, should be about the economic identity of our nation and we, as a country, are suffering from an identity crisis.

Our founding fathers in framing the United States Constitution established our form of government but did not set laws regulating the nature of the U.S. economy. They left us, the people, free to choose our path to economic success. They were wise to do so. Economies, unlike governments, need to adapt to changing times.

At its inception, the United States was largely an agrarian economy. Slavery was common as, morality aside, it was beneficial in an agrarian economy. Our founding fathers, even though philosophically conflicted over the ethics of slavery, maintained slaves on their plantations as a matter of economic necessity.

With the dawn of the Industrial Revolution in the 1800s, the economy shifted to a capitalist economy. The abolition of slavery in the industrialized North was consequently as much driven by economic policy as it was by a humanitarian one. It was simply cheaper to pay a man low wages for a day's work than it was to provide food, clothing and shelter to that man and his family as slaves. Following the Civil War, slavery was abolished in the agrarian South as well. With freedom no longer an issue, the attention of the masses turned to the concept of fairness in the wages being paid.

Labor movements characterized the social upheaval of the early 1900s, culminating in the elimination of the last remaining ruling monarchies in Europe and the establishment of Communism in Russia in 1917. Socialism, as a hybrid between capitalism and communism, evolved as the economic framework across most of Europe and throughout the United States to quell the political unrest associated with these labor movements.

However, socialism and capitalism mix about as well as oil and water. At its core, capitalism is about the rights and efforts of individuals within a society. The role of government in a capitalist economy is to protect the rights of individuals and foster the ability of individuals to prosper in accordance with their efforts and abilities. The essence of socialism is collectivism. The rights of individuals are subordinated to the needs of society. Those who have more have an obligation to provide for those who have less. The role of government is to enforce that obligation.

These philosophies are incompatible and the effort to fuse them over the last century has crippled the progress of capitalism. It is the reason why Standard & Poor's has downgraded the credit ratings of the United States, France, Italy and Spain. It is the reason why Greece has become insolvent. It is the reason why the world today is teetering on the brink of an economic meltdown as nation after nation spends more on social programs than it has the means to afford.

The conflict between capitalism and socialism is not, as the socialists within our government would have us believe, about business versus unions, employers versus employees. Collective bargaining, with or without unions, is a part of capitalism. Employers have no inherent right to impose artificially low wages on their employees. Doing so violates the right of each and every employee to prosper in accordance with his or her individual effort and ability, which is the basic premise of capitalism. Employees have the right to negotiate contracts with their employers and capitalism as an economic model ceases to perform at its best when that right is impeded.

Socialism is not about earned wages and benefits. Rather, it is about the redistribution of wealth from those whose efforts and abilities have allowed them to prosper to those who have not. It is about power acquired by pandering to a public unwilling to provide for itself. It is about the expansion of government to provide an ever enlarging array

of products and services to a population that has not earned them. It is about interference with free market dynamics to essentially enslave one segment of the population to serve the needs of the rest.

Healthcare has been caught in the crossfire between capitalism and socialism since 1945. In framing the rhetoric for debates on the subject, socialists have focused on the concept of healthcare as a basic right. In fact, healthcare has so frequently been described as a basic right to citizens of developed countries that this characterization as a "right" is beginning to pass as an established fact. Some would almost have us believe that the framers of the United States constitution established healthcare in addition to life, liberty, and the pursuit of happiness as one of the inalienable rights of U.S. citizens. Nothing could be further from the truth.

Basic rights are elemental. They are intrinsic to the human spirit. As such, basic rights carry three essential characteristics. First, a basic right cannot require a product or service to be provided by another human being as nothing intrinsic to the human spirit can be dependent on an extrinsic source. Second, a basic right cannot be taken from a citizen without just cause. Finally, a basic right cannot violate another basic right. Thus, because life is a basic right, we cannot be deprived of life without just cause. However, the need for food, clothing and shelter to sustain life does not endow us with the right to simply seize the food, clothing and shelter that we may need since doing so would violate the rights of those who possess the food, clothing and shelter we seized. In fact, no product or service provided by another human being can be validly characterized as a right as doing so would inevitably enslave the provider of the product or service and therefore deprive that human being of the basic right of liberty without just cause. Since healthcare cannot be provided to any individual without the services of other human beings, healthcare cannot be a right.

So, if healthcare is not a right, what is it? Most everyone would agree that there exists a basic need for healthcare. In meeting that

need, healthcare qualifies as a **benefit**. So, in framing the healthcare debate in this country, it is not appropriate to insist that our citizens have a right to a government provided healthcare program to meet their needs but, rather, how do we best provide a benefit to our population. As with most benefits, there is no one-size-fits-all approach. As a result, the argument over how to best provide this particular benefit has been contentious.

Few issues have, in fact, stirred more heated argument or so firmly polarized proponents and opponents of socialism and capitalism as healthcare. It is not difficult to understand why. Healthcare is a topic that affects us all. At some point in time regardless of age, sex, race and financial status we all will encounter a need for healthcare. It is, consequently, along with food, shelter, and clothing, a universal need.

This universal need for healthcare has led to the development of programs to expand the access to healthcare. The first such movement occurred in the 1940s as the labor unions negotiated healthcare benefits for union members and their families as part of the payment due them from their employers and successfully lobbied the federal government to exempt those healthcare benefits from taxation. This eliminated the barrier to the access to healthcare for hundreds of thousands of Americans as employers across the country expanded healthcare coverage to employees irrespective of union membership.

This increase in access to healthcare produced a corresponding increase in the demand for services, fueling the growth of healthcare institutions in the United States. Hospitals, with the assistance of local and federal tax subsidies, were constructed so that few communities were without at least one local hospital by 1970. Medical schools flourished as did research largely funded through the National Institutes of Health. With the increase in medical education came a corresponding increase in specialization. While two thirds of physicians were

in general practice in 1930, by 1970 two-thirds of physicians were in specialty practices.

The expansion of medical specialties and medical research served, in turn, to foster the need for the development and production of drugs to treat the conditions being more readily diagnosed. A myriad of pharmaceutical companies worldwide arose to fill that need. Private institutions, not government, largely funded the research, development, production and distribution of pharmaceuticals. A complex relationship between private and public institutions consequently evolved. Medical schools needed information from the pharmaceutical companies to train emerging doctors on the drugs available to treat the conditions they were being taught to diagnose in their clinical training. Pharmaceutical companies needed the relationship with teaching institutions to embed their products in the treatment protocols being taught and thereby establish their markets.

The expansion in medical research, medical education, hospital construction, specialty practice and pharmaceuticals served to further increase the utilization of medical services and fan the flames of need that led to the initial expansion. This increase in both the utilization and complexity of care led to rapid increases in the cost of medical care, with the cost of healthcare nearly doubling between 1950 and 1960. This increase in cost fostered the development of health insurance companies in the same decade to provide employers with policies to insulate them from the unpredictable and rising healthcare costs of their employees.

Thus, healthcare in post-World War II America developed largely as an employer-based benefit. But this pattern of development, while serving the employed recipients of healthcare admirably, was not without its detractors. Virtually from the beginning, there existed forces which favored a public universal healthcare system over a

private employer-funded healthcare system. Understanding the core values underlying the conflict between the supporters of employer-based healthcare and the supporters of government-run healthcare is critical to understanding what is truly at stake in the healthcare debate today. With healthcare representing 18% of the U.S. economy, this is truly a debate over the economic and political identity of our country. The eventual outcome of this debate will determine whether we move forward as a capitalist nation or join our European predecessors as a socialist nation.

Chapter One

Medicare and Medicaid

As early as 1949, President Truman introduced legislation to create a universal healthcare program under a national health insurance board within the Federal Security Agency to be funded by a mandatory 1.5% payroll deduction from employees and a matching contribution from employers.[1] While introduced annually to Congress throughout his second term in office, legislation enacting universal healthcare as a publicly funded benefit was never passed. Then, as now, it was viewed as a path to socialism and incompatible with the philosophical under-pinnings of a nation dedicated to the principles of capitalism. There was also, at the time, little impetus for change.

Employer-based healthcare in 1949 was still relatively new and served the needs of the majority of our population satisfactorily. It could never, however, meet the needs of our entire population and, over time, the clamor for programs to do so grew louder. Three broad groups, in particular, pointed to the inadequacy of employer-based healthcare as the solitary model for healthcare in the United States. Those three groups are the unemployed or marginally employed existing at or below the poverty line, the disabled, and the retired population.

The first two of these three were the easiest to address. The turmoil of the 1960s led to the end of overt racial discrimination and an expan-sion of our collective social conscience. It was increasingly accepted that American society needed to atone for its previously repressive behavior, behavior which had held the African-American population in the bonds of slavery and then, upon freeing them, denied them an

equal right to succeed as Americans. Catharsis required that we, as a society, facilitate advancement of minorities beyond the bonds of poverty. Affirmative action programs were enacted to accomplish this and it was only a natural extension of these policies to enact legislation that would assure the poor access to appropriate medical care. The addition of Title XIX to the Social Security Act in 1965 served that purpose by establishing Medicaid. The addition of the second group, the disabled who were poor through no fault of their own and for whom society had a moral obligation to provide care, was never in question.

Medicaid was established as a program jointly funded by the federal government and the states, with state participation on a voluntary basis. Funding at the federal level was initially derived from the social security taxes collected and generally matched the funding provided at the state level. Because of the voluntary nature of state participation, the eligibility requirements and the services provided under Medicaid varied from state to state.

The third group, the retired population, was now easier to address. The increasingly pervasive opinion that a society has an obligation to provide all the needs of all its members made inevitable the decision to cover medical costs for the elderly following the decision to cover medical costs for the poor and disabled.

With a few exceptions, employer-based healthcare ceased when employment ceased. When few people lived into retirement, this was not a problem. However, the intensity and quality of healthcare services that followed the inception of employer-based healthcare led to longer life spans and served to underscore the inadequacy of employer-based healthcare as a solitary approach to meeting the healthcare needs of the nation. In 1900 the average lifespan was 47 years[2]. By 1965, the average lifespan was 70 years[2]. At the time of this writing the average lifespan is 79 years[3].

At the same time, the earnings of the average individual post-retirement are far lower than during their employed years while the need for healthcare and the cost of healthcare are at their greatest. Enactment of a publicly funded program similar to Social Security to provide for the medical needs of the elderly was, consequently, viewed as necessary by 1965 and led President Johnson to introduce and help pass legislation establishing Medicare as the healthcare program for the retired and disabled population.

The initial requirements for Medicare eligibility were set by age and disability. Then, as now, eligibility for Medicare began at age 65 for non-disabled adults. Disabled individuals were eligible for Medicare if entitled to Social Security disability benefits for the preceding 24 months. Permanent kidney failure also served as eligibility for Medicare after 1972.

In establishing the operational framework for Medicare, the federal government essentially borrowed the existing framework from the private insurers. Thus, payment for inpatient hospital care was separated from payment for out-patient services. Medicare Part A (also referred to as hospital insurance or HI) was established as mandatory coverage after age 65 and provides a 90 day benefit period for inpatient hospital care. Coverage includes a semi-private hospital room, operating room expenses, anesthesia, imaging studies, diagnostic labs, drugs administered while in the hospital, and blood transfusions with a 3 pint deductible. Those insured by Medicare are responsible for an initial deductible after which Medicare then pays 100% of the charges for the first 60 days of hospitalization. From days 61-90, those insured by Medicare are responsible for daily co pays. If the hospital stay exceeds 90 days there is a lifetime 60 day reserve to extend the benefit period.

Medicare Part A also provides limited payment for stay in a skilled nursing facility. To qualify, those insured by Medicare must first have

spent at least 3 days in a hospital prior to transfer to a nursing home and admission to the nursing home must be for the same reason as admission to the hospital. If these conditions are met, Medicare then pays 100% for 20 days. From days 21-100, those insured by Medicare are responsible for a daily co-payment. Medicare pays no benefits beyond 100 days.

Medicare Part B (also known as supplemental medical insurance or SMI) is the framework for payment of out-patient services. This is optional for the Medicare insured and covers a wide range of services provided for illnesses that do not require hospitalization. These include doctor visits, physical therapy, x-rays and lab tests performed in the United States. Medicare Part B does not pay for prescription medication, dental care, podiatry, routine physicals, private nursing care, custodial care of any sort, and care received outside the United States.

Funding for Medicare Part A is provided by a 1.45% tax on employee wages with a matching employer contribution. Funding for Medicare Part B is from premiums charged by the federal government to those insured by Medicare.

The tax on employee wages was initially established as part of the nation's social security tax. Unlike Medicaid, however, all funding for Medicare was provided at the federal level. Consequently, the total Medicare tax paid was limited by the income limit for payment of the social security tax. With the passage of time, this funding mechanism proved problematic. Increases in expenditures related to increasing lifespan, medical inflation and increased utilization led to larger and larger portions of the funds earmarked for social security being used for Medicaid and Medicare expenses.

Largely to address this problem, Congress in 1977 created The Healthcare Financing Administration (HCFA) within the Health and Welfare Administration to administer both Medicare and Medicaid.

With the creation of HCFA, funding of Medicare and Medicaid was separated from funding of Social Security. The creation of the Centers for Medicare and Medicaid Services (CMS) further separated the administration of Medicare and Medicaid from the administration of Social Security. The income limits applied to the collection of Social Security taxes were therefore no longer imposed on the collection of Medicare and Medicaid taxes.

To illustrate, the social security tax is limited to 6.2% of the first $110,100 of earned income in 2012 with a matching contribution from the employer. Thus the maximum social security tax that could be collected per employee is $13,652.40 (12.4% of $110,100). The Medicare tax rate for 2012 is 1.45% of income with a matching contribution from the employer. If the same income limits applied to the Medicare tax as apply to the Social Security tax, the maximum Medicare tax that could be collected per employee would be 2.9% of $110,100 or $3,192.90. The total maximum combined Social Security and Medicare tax that could be collected on behalf of any employee regardless of income would be $16,845.30.

By separating the Medicare tax from the Social Security tax, the federal government was able to eliminate the taxable wage base limitation for the Medicare tax. Thus, an executive earning $1,000,000 would still pay $6,826.2 in Social Security tax but would now pay $14,500 in Medicare tax. His employer would match the $6,826.2 and $14,500 on behalf of this employee for a combined payment of $13,652.4 for Social Security and $29,000 for Medicare on behalf of this employee in 2012. The Social Security and Medicare taxes now collected on behalf of this employee total $42,652.40 rather than the $16,845.30 payable before the taxes were separated.

This separation of the Medicare tax from the Social Security tax has served to substantially increase the revenues paid into Medicare

and Medicaid from payroll taxes while simultaneously increasing the proportionate share of Medicare and Medicaid taxes paid by employees with higher earnings and their employers who match those tax payments. This shift in funding created a subtle but powerful, and increasingly pervasive, shift in attitudes in America. With the passage of three decades since the formation of HCFA, Americans have become more accepting of the single basic principle governing socialism—those who have more have an obligation to provide for those who have less and it is the role of government to redistribute wealth from those who have more to those who have less in order to enforce that obligation. This fundamental principle of socialism enabled President Obama with a democratic majority in the House of Representatives and a democratic majority in the Senate to take a risky gamble. In spite of the deepest recession since the Great Depression, in spite of massive government spending which would serve to double our national debt in only 4 years time, President Obama and a democratically controlled Congress pushed through and passed into law a massive expansion of healthcare entitlements under the Patient Protection and Affordable Care Act.

Chapter Two

The Patient Protection and Affordable Care Act

The Patient Protection and Affordable Care Act was signed into law by President Barak Obama on March 23, 2010. It has since been more commonly known as ObamaCare. No single piece of legislation in my memory has stirred as much controversy nor has any single piece of legislation been so poorly understood. In an effort to provide clarity, I will address the positive and negative aspects of the legislation separately.

Let us start with the positives.

1. The legislation eliminates the lifetime maximum benefit which could be paid under most health insurance plans.
2. The legislation eliminates the exclusion of coverage for pre-existing conditions.
3. The legislation provides insurance for the previously uninsured.
4. The legislation expands eligibility for coverage of children under family plans to age 26.

The elimination of lifetime maximum benefits payable under health insurance plans is laudable and a definitely valuable benefit. Most health insurance plans carried a lifetime maximum benefit of $2 million. Individuals with chronic illnesses and consequent high annual healthcare utilization who did not meet the criteria for social security disability and consequent eligibility for Medicare and/or Medicaid became essentially uninsurable once they exceeded their lifetime maximum benefit. Because of the Patient Protection and Affordable Care Act, these individuals can no longer be pushed into bankruptcy

as a result of their illness or injury. Were I in this situation, I would be grateful for the new law. However, it did not require an overhaul of the entire healthcare system to accomplish this. Revising the rules for Medicare eligibility to allow for automatic inclusion of anyone who has exceeded their lifetime health insurance benefit limit would have produced the same outcome.

Eliminating the exclusion of insurance coverage for pre-existing conditions, while beneficial, has only limited impact. This issue was addressed earlier in the Health Insurance Portability and Account-ability Act (HIPAA) of 1996. HIPAA already prohibited insurers from denying coverage of claims for pre-existing conditions unless there was a lapse in insurance coverage which exceeded 90 days. The cur-rent legislation therefore only benefits those individuals who have a pre-existing condition and have been without insurance coverage of any sort, including Medicaid, for more than 90 days.

The verdict remains out as to whether a new program to insure the uninsured is actually beneficial. It is estimated that there are 40 million uninsured Americans. These are individuals whose income disqualifies them from Medicaid eligibility and whose employers do not offer health insurance. Many of these are young, healthy adults who would rather pay for any healthcare that they need when they need it rather than pay for healthcare insurance that they are likely to never use. In short, they have made a conscious financial choice to be uninsured. The Patient Protection and Affordable Care Act has now stripped these individuals of the right to make that choice. As of January 1, 2014 they are required to purchase insurance or subject themselves to an annual tax of 1% of adjusted gross income or $95, whichever is greater. In 2015 the tax rises to 2% of adjusted gross income or $325, whichever is greater. In 2016 the tax peaks at 2.5% of adjusted gross income or $695, whichever is greater[1]. Furthermore, because this has been determined to be a tax by

the U.S. Supreme Court, noncompliance with payment of the tax can now also result in the assessment of penalties of up to 25% of the tax owed as well as accumulated interest.

The final category under positive aspects of the legislation is the ability to retain "children" under a family policy to age 26. Like the pre-existing condition clause in the legislation, this is largely window dressing. Most health insurance plans already allow for continuation of coverage for any family member over the age of 18 who is enrolled as a full-time student. For students taking 6 years to conclude college, this would take them to the age of 24. The need to provide coverage under a parent's policy beyond this is either an acknowledgement of anticipated continued economic stagnation which will provide no employment opportunities for these students upon graduation or an indefinite prolongation of adolescence in a society that has lost its sense of productivity and individual responsibility. Retention of "children" over the age of 18 on a parent's policy that are not enrolled as full-time students is clearly the latter.

We must now turn to what are the negative aspects of the Patient Protection and Affordable Care Act. Unfortunately for the state of our nation, the negatives far outweigh the positives.

1. The legislation expands eligibility for Medicaid.
2. The legislation imposes hefty new taxes.
3. The legislation will decrease the quality of care and the access to care.
4. The legislation will massively increase our national debt.
5. The legislation will lead to economic stagnation and decline.
6. As a sustainable mechanism for healthcare reform, the legislation has failed even before it has been fully implemented.
7. The legislation promotes the formation of healthcare cartels.
8. The legislation moves us further along the road to socialism.

1. Expansion of Medicaid

There are many in this country who would argue that the expansion of Medicaid eligibility represents a positive effect of the legislation. So why am I including this under the negative effects? The answer is complex. The Patient Protection and Affordable Care Act increases Medicaid eligibility to 138% of the poverty line. The poverty guidelines from the Department of Health and Human Services for the 48 contiguous states and the District of Columbia for 2012 are listed in the chart on the next page.

2012 Poverty Guidelines for the 48 Contiguous States and the District of Columbia	
Persons in family/household	Poverty guideline
1	$11,170
2	15,130
3	19,090
4	23,050
5	27,010
6	30,970
7	34,930
8	38,890
For families/households with more than 8 persons, add $3,960 for each additional person.	

Thus, a family of four with household income at or below $31,809 (1.38 x 23,050) would be eligible for Medicaid. Now, I am not arguing that it is easy to support a family of four on $31,809, but I will argue that the eligibility determination for Medicaid is not really dependent upon this family's ability to live on $31,809. The poverty guidelines are based solely on income earned. The effect of other programs for the poor such as food stamps, energy assistance, aid to dependent children and housing subsidies are not considered. Because these are not considered, these programs do not alter the statistical picture of

poverty in the United States but do nonetheless serve to elevate the standard of living for these families and individuals. According to the director of health and welfare studies at the Cato Institute, Michael Tanner, the United States currently spends $82,440 per year to support this poor family of four noted above. This perpetuates government dependency and creates an enormous disincentive to leave the roles of welfare and earn a living. The expansion of eligibility for Medicaid under the Patient Protection and Affordable Care Act only adds to the problem.

Expanding Medicaid coverage, however, does more than just increase government dependency. It will also severely stress the healthcare system providing the care to Medicaid recipients. In those states in which Medicaid expansion will be the largest, the payment for services under Medicaid is the lowest. The following map shows the ratio of Medicaid payment relative to health insurance payment for each state. The Patient Protection and Affordable Care Act is projected to add another 16 million people to the Medicaid programs in these states. In California alone, another 1.6 million people are expected to enter the Medicaid roles. With reimbursement for services at only 38% of private health insurer reimbursement, the additional members are likely to overwhelm the physicians and hospitals whose profit margins are already lean and either render them insolvent or result in their refusal to provide care for this expanding population. California is not unique. Most states with large Medicaid populations pay less than 50% of private insurer rates as illustrated on the next page.

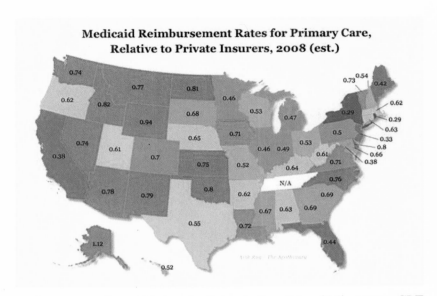

Medicaid Reimbursement Rates for Primary Care, Relative to Private Insurers, 2008 (est.)

I am currently practicing medicine in the state of Minnesota. CPT (Current Procedural Terminology) codes are used to classify the services for which we bill. The typical CPT code for a follow-up visit is 99213. The state of Minnesota currently pays 51.00 for a Medicaid patient seen for a follow up and billed under CPT code 99213. This is a 15 minute visit. I presently pay my receptionist $21/hour, my transcriptionist $23/hour and my billing staff $26/hour. Their combined salaries are $70/hour. As an employer, I am required to pay an additional 0.0765% of their salary for Social Security and Medicare raising the hourly rate by .0765 x 70 or $5.36 to $75.36/hour. Therefore, for each 15 minute appointment, my office staff costs me $18.84. For each 15 minute appointment, my office rent costs me $17.86. Health insurance for me and my 3 employees costs $3,003.41 with a $2,500 deductible. My health insurance cost for each 15 minute appointment is therefore $5.36. My advertising expenses are $16,000 per year or $2.38 per 15 minute visit. My malpractice insurance is $12,000 per year or $1.79 per 15 minute visit. My expenses for staff salaries, rent, and health insurance, malpractice insurance and advertising are there-

fore $18.84 + $17.86 + $5.36 + $1.79 + $2.38 or $46.23. Were there no other expenses such as office supplies, postage, telephone, internet, continuing education, travel, legal fees, etc., my earnings per Medicaid appointment would be $51-$46.23 or $4.77. Holidays reduce the work year by 2 weeks. Therefore, if I spend the requisite 1 week per year in continuing education classes and take 2 weeks per year for vacation, I have 47 weeks per year in which to earn an income. If all I saw were Medicaid patients, I would earn $19.08/hour (4 x $4.77), $133.56/day, $667.80/week or $31,386.60 per year. However, these figures assume that every available appointment is filled and there are no cancellations or missed appointments. Assuming a more realistic appointment rate of 80% of capacity, my income drops to $25,109.28 for the year. Furthermore, my actual annual income would be far less as there are many more expenses involved in running a practice than the 5 items for which I have accounted.

As a consequence of the meager rates of payment for services under Medicaid, 31% of physicians in the U.S. are already refusing to accept new Medicaid patients[2]. This percentage is likely to increase sharply as the Medicaid population expands making it more difficult for the poor to receive the care they have been promised under the Patient Protection and Affordable Care Act.

The expansion of Medicaid eligibility will also serve to sharply strain the already strained budgets at the state level. States are being required to invest in technology to establish health insurance exchanges through which individuals can shop for health insurance. These exchanges need to be sophisticated and will consequently be costly to develop and maintain. In addition, while the federal government is offering to initially cover 100% of the additional Medicaid spending consequent to increased enrollment, this is not permanent. Typically, the federal government pays only 50-57 % of the states'

Medicaid expenses, with the wealthier states receiving the lesser percentage. On average, Medicaid expenditures accounted for 22% of each state's budget in 2008. Once the initial federal funding of the Medicaid expansion ceases, the added costs will substantially drive up the portion of the state budget dedicated to Medicaid. These additional funds can only come from either higher state taxes imposed on the populace or yet lower payments to physicians, hospitals and other healthcare professionals or a combination of both.

2. A Bevy of New Taxes

To fund this massive increase in entitlement spending, the Patient Protection and Affordable Care Act imposes a massive increase in federal taxes upon our population. Though these tax increases are advertised as a tax on millionaires who can afford to pay more of their "fair share," the actual fact is that they fall squarely on the middle class. The threshold for the increase in taxes is individuals earning $200,000 or more per year or couples earning $250,000 or more per year. Many of these are small business owners working 80-100 hours per week. Thus, a husband and wife working a small business together, each working 80 hours per week, earning a total of $250,000 per year is no different than a husband and wife each working 40 hour per week at two jobs, with each job paying $62,500 per year. In both cases, these individuals will be taxed substantially more because they are ambitious and willing to work, but in neither instance are these individuals rich.

With the expiration of the Bush era tax cuts, these individuals will see their federal tax rate increase from 33% to 36%. Furthermore, this couple will see their Medicare tax increase by 0.9% from 2.9% to 3.8% on any income they earn in excess of $250,000 as a consequence

of the Patient Protection and Affordable Care Act[3]. If these individuals also have dividend income, that income, previously taxed at 15%, will now also be taxed at 36% plus an additional 3.8% Medicare tax from the Patient Protection and Affordable Care Act creating a dividend tax of 39.8%[3]. Their long-term capital gains tax will also increase from 15% to 20% plus a 3.8% Medicare tax from the Patient Protection and Affordable Care Act changing their tax on long-term capital gains to 23.8%[3]. The truly rich, those earning $1,000,000 or more per year will pay only slightly more. They will have a maximum federal tax rate of 39.6%. With the addition of the 3.8% Medicare tax from the Patient Protection and Affordable Care Act, their dividend tax increases to 43.4%. Their long-term capital gains tax is the same 23.8%.

Pursuant to the U.S. Supreme Court ruling on The Patient Protection and Affordable Care Act, effective January 1, 2014 anyone not purchasing "qualifying" health insurance as defined by the Department of Health and Human Services will be subject to a federal tax. In 2014 that tax is the higher of 1% of adjusted gross income or a minimum of $95 for a household with one adult, $190 for a household with two adults, and $285 for a household with three or more adults[1]. Thus an individual supporting a wife and one adult child with an adjusted gross income of $50,000 would incur a tax of $500.

In 2015 the tax rises to the higher of 2% of adjusted gross income or $325 for a household with one adult, $650 for a household with two adults, and $975 for a household with three or more adults[1]. This same individual supporting a wife and one adult child with an adjusted gross income of $50,000 would now pay a tax of $1,000.

In 2016 the tax again rises to the higher of 2.5% of adjusted gross income or $695 for a household with one adult, $1,390 for a household with two adults, and $2,085 for a household with three or more adults[1]. This same individual supporting a wife and one adult child

with an adjusted gross income of $50,000 would now pay not 2.5% of adjusted gross income ($1,250) but $2,085.

There are also taxes on employers who fail to offer health coverage for their employees. Effective January 1, 2014 any employer with 50 or more employees who does not offer "qualified" health insurance coverage for his/her employees and who has at least one employee who qualifies for a health tax credit, will face an annual non-deductible tax of $2,000 per full-time employee. If any employee actually receives health insurance coverage through the state's health insurance exchange, the tax for that employee increases to $3,000. If an employer requires a waiting period of 30-60 days before an employee is eligible for health insurance, there is a $400 tax per employee. If the waiting period exceeds 60 days the tax per employee increases to $600[4].

Effective January 1, 2014 the Patient Protection and Affordable Care Act also imposes an excise tax on health insurance companies. This is a complicated tax. Small insurers whose premiums collected are less than $25,000,000 per year are exempt from the tax as are companies whose third party administration fees are less than $5,000,000 per year.

The remaining companies are taxed according to their percentage of the market and their volume of business. Companies whose annual premiums are greater than $25,000,000 but less than $50,000,000 are taxed at 50% of their excise tax rate. Companies with over $50,000,000 in annual premiums are taxed at 100% of their excise tax rate. Companies with more than $5,000,000 but less than $10,000,000 in annual third party administration fees are taxed at 50% of their excise tax rate. Companies with more than $10,000,000 in annual third party administration fees are taxed at 100% of their excise tax rate[5].

The company's excise tax rate is determined by calculating the company's market share. Thus, a health insurer with a 10% market share with premiums exceeding $50,000,000 per year and third party

administration fees exceeding $10,000,000 per year would pay 100% of 10% of the amount set for the excise tax on all insurers. That tax is currently $6,700,000,000. This company would thus be liable for 10% of $6,700,000,000 or $670,000,000 in tax.

The tax is calculated by the Secretary of Health and all insurers are required to report all necessary data by the date determined by the Secretary following the end of any calendar year. Failure to report will incur penalties of $10,000 plus $1,000 per day of delinquency up to the amount of the tax owed[5].

This excise tax on healthcare insurers will have substantial unintended consequences. First, it will likely result in the health insurer market consolidating in the hands of a few large key insurers, thereby restricting consumer choice. Small insurers lack the economies of scale that the large insurers posses and nonetheless will still need to outspend large insurers on advertising to gain name recognition. The profit margins of small insurers are therefore likely to be smaller than those of the large insurers and those profits are at risk of be entirely erased by an excise tax imposed consequent to growth. For example, if an insurer with a 1.0% profit margin has grown its premium sales from $20,000,000 to 30,000,000, its profit is $300,000. If this company's market share is 0.0035% of the premium market, it would owe $117,250 in taxes, as its tax basis is 50% of sales, leaving an after tax profit of $182,750. However, this company's profit on $20,000,000 in sales the previous year when it was exempt from the tax at was $200,000. The increase in profit consequent to the increase in sales has been entirely lost along with a portion of the profit prior to the increase in sales. With less profit to fuel future growth, the company will need to further reduce its profit margin to cover the added expenses.

If the next year the company spends more to increase sales to $60,000,000 and their profit margin drops to 0.7%, the company's

profit is $420,000. However, the company's market share is now 0.007% and its tax basis is 100% of sales. The company's tax is now $470,340, exceeding its profit for the year.

Faced with this dilemma, most small and mid-sized companies with lean profit margins will exit the market. Their exit may even be hastened by reductions in profit margins voluntarily taken by the large insurers in what amounts to government facilitated predatory pricing. These reductions will be applauded by the federal government as proof that the Patient Protection and Affordable Care Act is working to reduce healthcare cost. Once competition has been eliminated, however, the large insurers will increase their prices to recoup their losses, erasing the illusory savings attributed to the efficacy of the Patient Protection and Affordable Care Act and leaving us firmly in the grip of a healthcare cartel.

Secondly, the excise tax will serve to increase the cost of healthcare for all consumers. This may occur with or without the above scenario. With the above scenario, the increase will occur later. Without the above scenario, the increase will be immediate. United Health Group, for example, had revenue of $102 billion in 2011. Raising its rates 2% more than the projected increase for the next calendar year, say from 7% to 9%, would raise $2 billion to cover the cost of the tax. That increase in premium effectively transfers the cost of the tax to all consumers of healthcare.

The Patient Protection and Affordable Care Act also imposes an excise tax on employer-sponsored comprehensive health insurance plans. This tax takes effect January 1, 2018. It is a 40% tax on "Cadillac" health insurance plans. A "Cadillac" plan is defined as insurance coverage which costs more than $10,200 per year for an individual or $27,500 per year for a family. In the case of employer-sponsored group health plans, the health insurer is responsible for paying the tax

but the employer is responsible for providing the Secretary of Health with the proper data. Failure to do so in a timely and accurate manner will result in a penalty assessed against the employer equal to the excess cost of coverage over the allowed amount plus interest[6].

While this provision of the Patient Protection and Affordable Care Act was, no doubt, intended as an incentive for the insurer to contain the rising cost of healthcare premiums, I am not certain that the consequences will be to the liking of either the professionals providing healthcare or the population consuming healthcare. This pressure to contain premium cost or face a significant excise tax will result in the insurers offering fewer covered services and lower payment for those services. Healthcare rationing by 2018 will consequently be inevitable.

Effective January 1, 2010 The Patient Protection and Affordable Care Act also imposed an excise tax on pharmaceutical companies engaged in the development and production of new drugs[7]. This tax is complicated and convoluted. Orphan drugs used only for orphan conditions are exempt from the tax. Generic drugs are also excluded from the tax except for quasi-generic drugs approved under Section 505(b)(2) of the Federal Food Drug and Cosmetic Act.

The law does not establish reporting requirements for the pharmaceutical companies. Rather, the tax is determined by the Secretary of the Treasury from data provided by the Department of Health and Human Services, the Veterans' Administration, the Department of Defense and "any other source of information available to the Secretary of the Treasury." In essence, unlike any other tax levied, the Secretary of the Treasury determines the amount of the tax owed, not the accountants for the entity being taxed.

The amount of the tax owed is based upon the market share of brand name drugs held by each individual company and the percentage is tiered based on market share.

A company with $5 million in annual brand name sales or less pays	0%
A company with more than $5 million but not more than $125 million pays	10%
A company with more than $125 million but not more than $225 million pays	40%
A company with more than $225 million but not more than $400 million pays	75%
A company with more than $400 million pays	100%

These percentages are used to calculate the "sales taken into account." Thus, for a company with $300 million in brand name sales, the "sales taken into account" would be 75% of $300 million or $225 million.

The "sales taken into account" is now divided by to total sales of brand name drugs to determine the percentage tax owed by the company. If we assume the total brand name sales are $30 billion then the percentage owed by this company would be $225,000,000 divided by $30,000,000,000 or 0.75%. This is the company's "ratio."

To determine the tax owed by the company that ratio is applied to the "applicable amount." This amount is presently set to grow annually as follows:

2011	$2.5 billion
2012	$2.8 billion
2013	$2.8 billion
2014	$3 billion
2015	$3 billion
2016	$3 billion
2017	$4 billion
2018	$4.1 billion

Thus, in the case above, the company with $300 million in brand name sales would incur a tax of 0.0075 x $2,500,000,000 or $18,750,000, representing 6.25% of annual sales. Also, if this company's ratio remains the same, its tax will grow to 0.0075 x $4 billion or $30 million in 2017.

Unlike physician, hospital and medical equipment charges, the prices for brand name prescription medications are not set by federal or state governments and they are not set by private insurance companies. The pharmaceutical companies do have the ability to set the price for any new drug that they bring to market. Consequently, it is not likely that the pharmaceutical companies will simply absorb this new tax and reduce their profits. The tax will be factored into the price of each new drug. This tax is consequently inflationary in its impact. These increased pharmaceutical costs will be reflected in the insurance premiums paid by employers and individuals. These tax revenues from the pharmaceutical companies do, in other words, simply translate into an indirect tax levied on employers and consumers of healthcare through higher premiums and/or higher prescription co-pays. Those who are receiving their healthcare through private programs will pay more in order to provide the pharmaceutical companies with revenue to pay the taxes to subsidize the public programs—billions of dollars more. As pharmaceutical costs for public programs will also rise, however, these taxes on pharmaceutical companies will additionally spur an increase in direct taxation on all workers to cover the increased cost of pharmaceuticals. The bottom line is that nothing has ever been made cheaper by taxing it more. This is not a valid funding vehicle for "Obamacare." It is a shell game, pure and simple.

While the taxes imposed on the pharmaceutical companies can, and most likely will, be passed on to consumers, the increased cost of new pharmaceuticals will make it harder for these companies to

penetrate markets, recoup their investment in the development of their drugs and then generate a profit. Federal and state governments along with private insurers have been aggressive in their mandate for the use of generics over brand name drugs in virtually all circumstances. It is likely that they will further strengthen these mandates. These barriers to bringing a new drug to market only serve to further increase the cost of any new drug. If, ultimately, those barriers cannot be penetrated and the market for a new drug shrinks, this only further increases the cost of that new drug. These factors have already combined to slow the development of new, more effective and safer drugs. This will continue, resulting in stagnation in this extremely important arena of healthcare and a consequent decline in the standard of care relative to what we have come to expect in a country dedicated to innovation.

The Patient Protection and Affordable Care Act also provides for an excise tax on medical device manufacturers. This is a 2.3% exise tax to be paid by manufacturers to the federal government on the sale of medical devices starting in January of 2014[8]. In a free market, these manufacturers would adjust the price of their products to reflect the tax. Healthcare in the United States, however, no longer operates in a free market. The same federal government imposing this exice tax on these manufacturers also sets the rate under Medicare that will be paid for their devices. The private health insurers do the same. Consequently, doctors and hospitals purchasing these medical devices are in no position to pay more for the products if they are unable to bill and receive more from the federal government or private insurers for the use of these products.

This tax consequently must be borne either by reducing the profits of the medical device manufacturers or by further reducing the already meager profits of doctors and hospitals operating within this system. If the device manufacturer is unable or unwilling to absorb the cost of this tax and the doctors and hospitals are likewise unwilling or unable,

the device will fall into short supply as either production or orders are reduced. It is then that the patients in need of these devices will suffer. Items involved would include pacemakers, heart monitors, prosthetic devices for hip and knee replacements, hardware for spine surgery, stents for heart surgery and intrathecal pain pumps to name just a few. A number of device manufacturers have already warned that the tax would exceed their profits and drive them into insolvency.

Implementation of this tax on medical device manufacturers will have a chilling effect on research and development. These companies will become unwilling to invest in the development of new products if profit margins are too low to justify the investment. Such stagnation is also not in the best interest of healthcare consumers.

The Patient Protection and Affordable Care Act also penalizes individuals who have high medical expenses beyond those covered by their insurance plans. Current tax law allows expenses to be deducted if they exceed 7.5% of adjusted gross income. The Patient Protection and Affordable Care Act changes that threshold to 10%[9]. This will clearly serve to increase the taxes paid by the middle class.

The Patient Protection and Affordable Care Act also imposes a spending cap on Flexible Spending Accounts of $2,500 effective January 1, 2013[10]. Spending was previously uncapped. This provision will primarily impact working families with middle class incomes.

The Patient Protection and Affordable Care Act also eliminated the ability to purchase ove-the-counter medications with HSA funds effective January 1, 2011[11]. This has already served to increase the tax burden for working middle-income families.

The Patient Protection and Affordable Care Act also eliminates the tax deduction for employer-funded prescription drug coverage in coordination with Medicare Part D effective January 1, 2013[12]. This will increase prescription expenses for millions of seniors living on fixed-incomes.

The Patient Protection and Affordable Care Act also increased the penalty for early withdrawal of funds from an HSA for non-medical purposes from 10% to 20% effective January 1, 2011[13]. This provision particularly affected those individuals who lost employment as a consequence of the longest recession in American history and required these funds to meet expenses.

Effective January 1, 2013 The Patient Protection and Affordable Care Act amends Section 162 (m) of the Internal Revenue Code of 1986 to disallow deduction by a health insurance company for any executive compensation in excess of $500,000 annually[14]. Put more plainly, any health insurer paying executives more than $500,000 per year in total compensation will now also have to pay corporate taxes on the amount in excess of $500,000 per employee. This provision of the Patient Protection and Affordable Care Act will serve to limit health insurance executive compensation and was no doubt intended as a pre-emptive measure to kwell public outcry over health insurance executive excesses at a time when that public is being hit hard with measures to enforce healthcare rationing.

This measure is, however, more illusory than real. To explain, I will use United Health Group as an example. United Health Group is not a health insurer. It is a management corporation. The health insurance company within United Health Group is United Healthcare. Therefore, Stephen Hemsley, the CEO of United Health Group who was paid $48.8 million in 2011[15], will not see his income affected by this provision of the Patient Protection and Affordable Care Act. This provision will simply serve to limit the amount that United Health Group (upper management) is obligated to pay to its middle management executives staffing the positions in United Healthcare and thus increase the revenue flowing to upper management. In the event that upper management wishes to reward an individual at United Healthcare

beyond the $500,000 allowed under the new law, all that is required is to create a position for that individual in the management group and compensate that position with bonuses or stock options generated outside of the health insurance company and therefore exempt from this provision of the law.

Other insurers are likely to emulate this structure in order to blunt the impact of this legislation. Those that fail to do so will operate at an extreme financial disadvantage and will sooner or later be acquired by the larger entities that have done so, further consolidating the health-care industry and fascilitating the formation of a healthcare cartel.

Excesses in executive compensation will continue within these management groups. United Health Group is only one such management company. Express Scripts is a pharmacy benefit management corporation that paid its CEO $51.1 million in 2011[15]. CVS Caremark is a pharmacy benefits manager that paid its CEO $68 million in 2011[15]. Omnicare, the largest dispenser of pharmaceuticals to nursing homes (another management company), paid its CEO $98.3 million in 2011[15]. These excesses are not addressed by the Patient Protection and Affordable Care Act nor are they likely to be addressed in the future. The federal government and these management companies share a common goal—the ability to maximize revenue while minimizing expense. Revenue comes in the form of premiums collected for both the federal government and these management corporations. Expenses are primarily healthcare delivery costs and these expenses are best controlled by consolidating power into the hands of a few management companies working in concert with the federal government to control price and competition.

Effective January 1, 2010 the Patient Protection and Affordable Care Act modified the taxes on non-profit health insurance companies such as the Blue Cross/Blue Shield organizations to eliminate the 20%

reduction in unearned premium allowed under section 832(b)(4) unless 85% or more of premiums collected are spent on clinical services[16]. This requirement for a medical loss ratio of 85% in order to retain non-profit status and its attendant tax advantages has not served to restrain premium increases during the 2 years in which it has been in effect. Premiums did instead rise by 9% in 2011. Figures are not yet available for 2012.

Effective January 1, 2010 the Patient Protection and Affordable Care Act imposed a 5% excise tax on elective cosmetic medical procedures[17]. This tax is paid by the individual undergoing the procedure and is collected by the individual performing the procedure as part of his/her charge and then paid by that practitioner to the federal government quarterly. If the tax is not collected by the practitioner, the tax is owed by the practitioner.

This is clearly a consumer tax which will serve to increase federal revenue and discourage cosmetic procedures.

Effective January 1, 2010 the Patient Protection and Affordable Care Act imposed an excise tax on charitable hospitals that failed to "conduct a community health needs assessment which takes into account input from persons who represent the broad interests of the community served by the hospital facility, including those with special knowledge of or expertise in public health" and then "adopted an implementation strategy to meet the community health needs identified through such assessment." Hospitals which fail to meet these requirements will incur a $50,000 fine per hospital per year[18]. This measure places istitutions such as the various Catholic hospitals throughout the country at risk. If the community health need were to include the provision of abortion services as determined by members of the community outside the Catholic hospital system, the church would have to face the choice of weathering the fines, closing the hospital's doors, or violating its religious beliefs and allowing abortions to be performed at Catholic hospitals. This is a clear afront to religious freedom.

3. Erosion of the Quality and Access to Care

Closing the Catholic hospital system, as outlined above, would have an unmistakable impact on the access to care in the United States. These hospitals provide charitable services for millions of Americans across the country. This is, however, not the only threat to the access to care. The greater threat lies in the disappearance of medicine as a viable profession. To explain, we must first look at the overall structure of business in the United States.

The business structure of the United States can be largely divided into 3 groups—management, labor, and the professions. All corporations recognize sharp distinctions between these groups. Management exists to make the corporation more profitable and individuals are hired based upon their capacity to do so and then trained to further that ability. Largely, these individuals are rewarded in accordance with their success rate in achieving benchmarks of prosperity for their company.

Labor exists to perform the daily tasks that are needed to provide the product or service on which the corporation depends for its profits. For most corporations, labor is simply a necessary expense—an expense no different than the raw materials that a corporation must purchase in order to make its products. Just as it represents good management to pay as little as possible for quality raw materials, it is also good management to pay as little as possible for quality labor. This, not our tax structure, is what has been driving income inequality. For decades, the gap between executive and labor compensation has been widening into what has now become an enormous chasm. In 1980, the average CEO of an American company earned 42 times the average income of American workers[19]. By 2009, the average CEO was earning 263 times the average compensation of American workers[20]. By

2011. the average CEO was earning 380 times the average compensation of American workers[19].

The professions exist to provide individuals and businesses with expertise which is only occasionally needed. Thus, a company or individual will hire an architect for a specific project. The same company or individual will hire an attorney for a specific legal problem. As professionals, physicians have largely provided services to individuals, though they may be called upon occasionally to work on a specific project for a corporation. In these capacities, these various professionals act as consultants. They are neither management nor labor. They are independent contractors paid for the service that they provide. Because of the expertise required and the episodic nature of the work contracted, the various professions have charged and have received high rates of compensation for their services.

For the profession of medicine, this is changing and the Patient Protection and Affordable Care Act is accelerating the rate of change. One industry in particular, the health insurance industry, is consolidating its grip over all of healthcare and is transforming the profession of medicine into a healthcare industry in which management is the insurer and everyone else is labor. This transformation commenced with the introduction of physician networks in the 1980s and accelerated with the introduction of fee schedules in the 1990s. Integral to the independent nature of any profession is the ability of the professional to set his/her fees and to render opinions which are based on sound reasoning and are free from the bias exerted by labor or management. Unlike all other professionals, physicians are no longer able to set the fees that they charge. Those fees are dictated by the insurance companies in the private sector and by the federal and state governments in the public sector. This has been the first step in the elimination of the profession of medicine. The health insurance industry, once concerned

only with the finance of healthcare, has transformed itself into the healthcare industry, now overseeing the management of all healthcare in the United States.

This new management created a new terminology to explain its heirarchy. Doctors, nurses and all other healthcare professionals have been equally designated as "providers." To fully appreciate the meaning of this new terminology, read provider as labor. Management is comprised of the health insurer, the federal government and the state governments. As it is, and always will be, it is the intent of management to pay labor as little as possible. Physician incomes, relative to the hours worked, have consequently been declining for the last 20 years and will continue to do so.

This has dire implications for the quality of care and the access to care in the United States. Who in their right mind is going to spend the $250,000-500,000 and 12 years that it takes to become a physician in this country only to take on the unenviable position as labor? The physician community in America already recognizes this. 77.4% of physicians are somewhat pessimistic to very pessimistic about the future of the medical profession. 84% of physicians agree that the medical profession is in decline. 57.9% of physicians would not recommend medicine as a career to their children or other young people. Over 1/3 of physicians would not choose medicine if they had their careers to do over. Over 60% of physicians would retire today if they had the means. Over 52% of physicians have limited the access Medicare patients have to their practice or are planning to do so. Over 26% of physicians have closed their practices to Medicaid patients. Close to 92% of physicians are unsure where the health system will be or how they will fit into it 3 to 5 years from now[21]. Such pessimism and lack of morale does not translate into quality patient care.

Also reducing the quality of care and access to care is the provision for an Independent Payment Advisory Board (IPAB) within the Patient Protection and Affordable Care Act. The baby boom generation is entering retirement age. For the next 18 years, from 2011 to 2030, Medicare will be enrolling over 10,000 new members per calendar day. The Medicare trustees consequently anticipate 80 million enrollees in Medicare by 2030, double the 39.6 million enrolled by 2010. As outlined in the next chapter, this increase in the retired population is not matched by a corresponding increase in the workforce. In fact, the anticipated working population will be much smaller than it is today. Consequently, not even the bevy of increased taxes noted above will be sufficient to cover the cost of Medicare alone. The purpose of the IPAB is therefore to implement measures by which to contain cost without requiring the approval of Congress.

Finally, the above noted excise taxe on medical devices will create shortages and barriers to care. This tax and the tax on new pharmaceuticals will have a chilling effect on research and development and further reduce the quality and access to care.

4. Massive Increase in National Debt

It is estimated that The Patient Protection and Affordable Care Act will create another $2.5 trillion in spending over the next 10 years[22]. The taxes outlined above are projected to bring in about $500 billion in revenues over the next 10 years[23]. This leaves a $2 trillion shortfall which, if added to the $1 trillion deficit per year consequent to current spending, creates an additional $1.2 trillion added to the national debt each year. This would amount to $5 trillion added to the national debt within 4 years of full implementation of the Patient Protection and Affordable Care Act in 2014, bringing our national debt to $23 trillion by 2018.

5. Economic Stagnation and Decline

The regulations surrounding the Patient Protection and Affordable Care Act, particularly the taxes imposed by the legislation, will have a chilling effect on hiring for decades to come. There is little incentive to assume the risk of starting a business when the tax structure of a country works to limit the opportunity for success. There are fewer funds available for payroll when more of those funds are consumed by taxes. There is simply no way to tax and spend an economy into prosperity. Prosperity occurs when individuals are encouraged to work hard and invest in their businesses because they are allowed to retain a greater percentage of their efforts.

6. As Sustainable Healthcare Reform, the Legislation Has Failed

The Patient Protection and Affordable Care Act has failed as a mechanism for sustainable healthcare reform even before the legislation has been implemented. Why? Because it is employing a 40 year-old model with a proven track record of failure. Managed care has not worked. Had it worked, the nation would not be having the discussion over how to fix healthcare that we are having today. Had it worked, healthcare costs would not be 150% higher than they were 20 years ago. Yet the Obama administration has doubled down on managed care in an effort to fix our ailing healthcare system without first asking whether the management is the reason the system is ailing. Certainly, no one is listening to the physicians who have endeavored to work within this system for the last 40 years. But then why should they? Physicians are but labor in the new healthcare cartel and since when does anyone ask labor how to run an industry? To fully under-

stand why this system is doomed to fail, we must first explore the newly minted healthcare cartel.

7. The Formation of Healthcare Cartels

A cartel is a group of companies organized for the purpose of eliminating competition and controlling cost, usually with the assistance of the government under which they operate. One such example is the oil cartel, OPEC. Cartels do not operate to the benefit of the consumer nor do cartels offer much by way of opportunity for the labor that they employ. Cartels exist to maximize revenue for the management of the cartel.

With the passage of the Patient Protection and Affordable Care Act, the healthcare industry does now perfectly fit the definition of a healthcare cartel. Nothing about this is clearer than President Obama's statement in his second debate with Governor Romney that we must act to "reduce healthcare delivery costs." Read this as we must reduce what we pay labor. One mechanism favored by the Obama administration for doing this involves the formation of Accountable Care Organizations (ACOs). Here is how this process works. The federal government collects taxes from all workers in the form of Medicare tax. After paying the bureaucracy in Washington involved in the management of ObamaCare, the remaining sum is then sent to the states. After the state takes a portion of those funds to pay its bureaucrats, the state then awards the remaining funds to an insurer in return for providing all medical services to the population under contract. The insurer promptly places 25% of the remaining funds into its reserves. The insurer then offers medical practices designated by the state as accountable care organizations the opportunity to bid on the contract to provide those services. The contract would presumably go to the lowest bidder. Since the amount available to the accountable care

organization has already been reduced by the amount paid to the federal government, state government, and health insurer, the deck is already stacked against the ACO. The bidding process further reduces what will be paid to the ACO (labor) and simultaneously increases the profit for the insurer (management).

If this sounds like the classic HMO approach, it is because it is— only modified slightly to avoid the stigma. The doctors in the ACO are obligated by contract to provide all required care for the population under contract and are responsible for the cost of all care obtained outside of the ACO. In this regard, the ACO and HMO are identical. The difference lies in the population under contract. Under the HMO approach, individuals covered by the HMO who sought services out- side the HMO without referral from physicians within the HMO were responsible for payment of those services. Under the ACO approach, the ACO is responsible for payment of services obtained outside of the ACO with or without referral. Thus, if a given person is unhappy with his/her care, he.she is free to pursue care outside of the ACO. Such behavior has the potential to substantially increase the cost to the ACO, as the ACO would be responsible for payment for that care.

This arrangement represents a form of capitated reimbursement. In other words, physicians are given a payment for each person under contract and it is the reponsibility of the ACO to ensure that all neces- sary care can be provided for the sum alloted and still have the means to pay its staff. This form of reimbursement has always been preferred by the insurer as it shifts most of the financial risk involved in pro- viding care for a given population from the insurer (management) to the ACO (labor), while allowing the insurer a guaranteed profit in the form of the funds deposited into its reserves. Fee-for-service arrange- ments in which physicians are paid for the services provided do not create such a shift in financial risk.

The ACO has limited options by which to generate profit. The doctors in the ACO can focus more on preventive care and early detection to reduce the cost of care. This alone, however, is likely to reduce overall cost by no more than 4-6%. They can try to discourage excessive utilization. They can encourage the use of less expensive alternatives to high cost care. They can directly act to limit the care provided. All of these are methods of healthcare rationing. In adopting many of these measures, however, the ACO risks having their members seek care outside of the ACO, resulting in increased cost. It therefore comes as no surprise that 62% of physicians believe that Accountable Care Organizations (ACOs) are either unlikely to increase healthcare quality and decrease cost or that any quality/cost gains will not be worth the effort.

Even if a given ACO manages to succeed initially, it is likely that the federal and state governments will reward that success by reducing what they are subsequently willing to pay the insurer in future years. The insurer will correspondingly reduce what they are willing to offer to the ACO for the contract to be awarded. Profit margins will consequently shrink until failure is assured. This is not an undesired consequence from the cartel's perspective as I believe that it is the ultimate intent of the cartel to own the entire healthcare delivery system. As the ACOs are pushed into bankruptcy, the hospitals and clinics involved will be more easily acquired by the cartel. This consolidation will be sold to the public as a streamlining of healthcare to eliminate inefficiencies and improve productivity. However, its real purpose lies in the elimination of any resistance to healthcare rationing.

8. The Road to Socialism

As the entire healthcare delivery system in the United States falls under the control of a federally operated cartel, our nation moves sub-

stantially farther from capitalism and dangerously closer to socialism. Healthcare is, after all, 18% of the U.S. economy. From the Patient Protection and Affordable Care Act signed into law in 2010 to calls for an increase in the marginal tax rate for the top 2% of earners in the United States to efforts to increase the capital gains tax and thus redistribute the earnings on after-tax investment income in an effort to reduce income inequality, the drive toward socialism in the United States has never been clearer. At the same time, with a staggering $16 trillion dollar deficit for the U.S. Treasury and the impending financial collapse of one socialist economy after another in Europe, the stakes for Americans in the conflict between socialism and capitalism have never been higher. In the words of Great Britain's former Prime Minister, Margaret Thatcher, "The problem with Socialism is that sooner or later you run out of other people's money."

While healthcare is a social issue, the socialization of healthcare is not necessarily the best mechanism for addressing the issue. Government programs are inherently inefficient. Budgets for agencies are increased when funds are insufficient and budgets for agencies are reduced when efficient administration results in a surplus at the end of a fiscal year. Competence is punished and inefficiency is rewarded. The quality of our healthcare is too important to be relegated to such bureaucratic blundering.

At the same time, the private healthcare system as it exists in the United States is becoming unaffordable for the majority of Americans while insurance company profits and executive compensation have never been higher. Continuing the current insurance-run managed care system is no longer an option without either reducing the access to healthcare for the majority of Americans or severely rationing the healthcare provided. Neither approach is an acceptable option.

Sustainable healthcare reform therefore requires a fundamental restructuring of healthcare financing to make healthcare more afford-

able while simultaneously either preserving or increasing the access to healthcare. One of the strengths of employer-based healthcare is that it stands as an earned benefit for a company's employees, not yet another entitlement. It is the system through which the majority of Americans already receive their healthcare. It is the system by which remarkable advances in medical care have been achieved over the last sixty years, allowing us to live longer, healthier lives. This system need not, indeed should not, be abandoned. It does, however, need to be fundamentally restructured.

Our current systems for healthcare delivery are out of balance. The employers who pay for healthcare, the employees paying for and consuming healthcare and the physicians and other professionals providing healthcare are increasingly denied any voice in the healthcare that they pay for, receive or provide. Power in our current systems has been increasingly concentrated in the hands of the federal and state governmental agencies and the private managed-care insurers who, in a unilateral fashion, make all the decisions about healthcare delivery for us. Restructuring employer-based healthcare requires returning power to the stakeholders in the system. The stakeholders in employer-based healthcare are the employers who pay for healthcare, the employees who pay for and receive healthcare, and the medical professionals who provide healthcare. The stakeholders in our social programs for healthcare are the tax-payers that pay for healthcare, the population receiving healthcare, and the medical professionals who provide healthcare. The book that follows this chapter is about the process of restoring power to those stakeholders. It is about fundamentally changing how we finance healthcare delivery in the United States. It is about transforming an employer's greatest liability into a sizeable asset. It is about transforming a burden into a benefit.

Chapter Three

The Problem with Socializing Medicine

I began medical school at Loyola University-Stritch School of Medicine in Chicago in 1972. Medicare had by this time been in operation for six years during which time total Medicare reimbursement had risen 72% from $4.6 billion in 1967 to $7.9 billion in 1971. Physician fees had risen an average of 7% per year during this time and hospital charges increased an average of 13% per year[1]. The reasons for the increases include increased utilization, costly advances in technology, a liberal approach to Medicare reimbursement, and the tendency for government run programs to spend any and all funds allotted and then seek larger budgets for each successive year.

Whatever the cause, the federal government was now functioning as the health insurer for the elderly and the rise in health care costs spurred renewed interest in transforming health care delivery in the United States, with the principle goal of reducing the cost of health care delivery. By 1974 the government's preferred approach to containing cost appeared to be a socialization of all medical care under a single federal program. Richard Nixon introduced the Republican version entitled the Comprehensive Health Insurance Plan (CHIP) and the Democrats introduced their version in the Kennedy-Mills bill[1]. Ultimately, neither bill passed as skepticism ran high within the U.S. population regarding the government's ability to reign in cost without diminishing either the quality or access to care. Congress did, however, enact the Health Planning and Resources Development Act in 1974 which created over 200 agencies to oversee medical planning across the country[1] because, apparently in the eyes of the federal

government, more bureaucracy inevitably lowers costs.

Congress during this time also created Professional Standards Review Organizations (PSROs) to review patient care[1]. My first exposure to this, in fact my first exposure to government intervention in medical care, occurred while I was a third-year medical student. I was on a Hematology-Oncology rotation at Presbyterian-St. Luke's Hospital in Chicago. I had completed a history and physical exam on a woman in her late thirties who had been diagnose with acute granulocytic leukemia. I particularly remember this case because, in presenting the case to the oncologist serving as our mentor on this rotation, I referred to patient in her late thirties as a middle-aged woman.

The oncologist, a woman in her early forties, took strong exception to that characterization and never quite let me forget it. Anyway, within two days of the hospitalization of this woman, we received a form from the PSRO committee requiring an explanation as to why this patient was still in the hospital. The average length of hospital stay for acute granulocytic leukemia was two days and the government required an explanation as to why her stay exceeded the average. We replied, informing the PSRO that the average length of stay for acute granulocytic leukemia was two days because the average patient with acute granulocytic leukemia died in 1.5 days and we had managed to keep this woman alive. I had thought this reply would suffice. It did not. From that point until she was discharged from the hospital with her disease in remission, we received requests to justify continued hospitalization every two days. In essence, we were being asked to justify why we were still allowing this woman to live.

The same year that I started medical school, 1972, Congress also passed the End-Stage Renal Disease Program (ESRDP). Regina Herzlinger, a professor of business administration at Harvard Business School, cites this program as an example of the damage done to medi-

cal care in the United States by the U.S. Congress in her book, *Who Killed Health Care?* ESRDP transferred the cost of treating end-stage renal disease from private insurance to Medicare after 33 months of treatment regardless of age. As with Medicare, there was an unmet need which prompted the passage of the legislation. Because of the high cost of dialysis, only 1% of the patients with end-stage renal disease were able to receive dialysis. Thus, in spite of effective treatment options, tens of thousands of Americans with end-stage renal disease were left to die without access to effective treatment. Legislation to address this need, while laudable, unfortunately created yet another publicly funded program and all of the unintended consequences that inevitably follow publicly funded programs.

Government programs are generally reactive rather than proactive and the government's approach to the management of end-stage renal disease proved no exception to the rule. Not only was the government's program focused solely on treatment to the exclusion of prevention but Medicare's rules for reimbursement served to essentially dictate how treatment was provided and those dictates served to greatly inflate the cost of care while leaving the quality of care either unaltered or reduced. Between 1991 and 2004, Medicare's payments for the treatment of kidney disease more than tripled from $5.1 billion to $18.4 billion with no measurable change in death rates or hospital lengths of stay[2].

Medicare divided payments between dialysis, drugs and physician services, with payment heavily weighted toward covering the cost of drugs. This led to yet another problem with government run programs—they are susceptible to the influence of lobbyists. Anemia is a problem frequently encountered in patients with end-stage renal disease. Amgen is a pharmaceutical company that created a drug, Epogen, to treat this anemia. Amgen's lobbyists succeeded in getting

the FDA to grant orphan drug status to Epogen. This status meant that no similar drug could be approved by the FDA for a period of seven years. Achieving a monopoly in the treatment of the anemia associated with renal disease, Epogen sales grew from $840 million in 1998 to $2.4 billion in 2006. The majority of this increase occurred again as a consequence of Amgen's lobbyists. In 2005, Amgen spent $5.7 million lobbying Congress. That same year, the chairman of the Congressional subcommittee supervising Medicare's budget, advised Medicare to require physicians treating renal dialysis patients to raise their upper-end target for hematocrit, the measure of red blood cell count, by 3%. Achieving this required a 50% increase in the dose of Epogen. In 2006, a further increase in hematocrit of another 3% was mandated for physicians treating patients on renal dialysis, requiring another 50% increase in Epogen dose. The result was a doubling in revenues from the sale of Epogen for the pharmaceutical company, Amgen. The result for patients was an increase in the incidence of heart attacks and strokes directly related to the increase in hematocrit[2].

Professor Herzlinger further points out that Medicare's payment schedules under ESRDP favored large providers of dialysis services resulting in many independent dialysis centers failing and by 2006 leaving virtually all dialysis performed by two large dialysis chains, DaVita and Fresenius. Lack of competition has at least two potential unintended consequences. First, the lack of competition is inflationary as healthy competition generally serves to hold cost increases to a minimum. Second, lack of competition generally leads to a decline in consumer satisfaction as a monopoly has little fear of losing its customers. After all, where else can they go?[2]

The problem here is that bureaucracies establish protocols that they expect to be followed rigorously. There is no room for individual judgment. There is no room for innovation. This approach is inconsistent

with quality medical care and incompatible with a healthy doctor-patient relationship. It reduces the quality of care to a uniform level of mediocrity, stifles creativity and all but prohibits a patient-centered approach to treatment. If in fact you still harbor any illusions regarding government run health plans, consider the following excerpt from Professor Herzlinger's book.

> *As Professor Eli Friedman noted in his seminal 1997 article, "Health Care Engulfs All of Us," some European countries and Canada have rationed kidney care and/or penalized doctors who provided it to too many people. France attempted to reduce its annual expenditure for health care "by issuing 'Health Care Identity Cards' and tracking each physician's treatment costs. ... [P]hysicians who 'overspend' will have their reimbursement reduced— clearly a signal to ration expensive services...Canadian nephrologists are fixed by hospital and personnel funding reductions that constrain their acceptance of haemodialysis patients. As recounted by one, 'Each time I present a new patient for haemodialysis ... I am viewed as an enemy.'"[2]*

Rationing healthcare in terms of Medicare spending had in fact become a priority in the United States as early as 1971. Total Medicare expenditures had nearly doubled between the plan's inception in 1967 and 1971 from $4.6 billion to $7.9 billion[1]. Unable to stem the tide of inflation generally in the 1970's and medical inflation in particular, the federal government subsidized the development of HMOs in the hope that private plans would be better able to control cost. Despite reductions in physician payment, limitations on hospital admissions and lengths of stay, and restriction of visits to specialists and

out-of-network treatment, HMOs delivered only a brief reduction in healthcare costs. In some instances, by delaying access to more appropriate treatment, HMOs actually contributed to rising costs associated with delayed or inadequate care. Efforts to contain cost were in fact so ineffective that, by 1981, out-of-pocket healthcare expenses for the elderly were only 1% lower than they were before the implementation of Medicare[3].

To simultaneously address these rising out-of-pocket costs for the elderly and reign in the rise in Medicare Part B expenditures, Congress established the Medicare Economic Index (MEI) in 1975. This index measured the changes in the cost of physician's time and operating expenses. Changes in physician's time were calculated using changes in nonfarm labor costs. Improvements in productivity by physicians were used to reduce the rate of growth. In other words, increased efficiency on the part of physician practices acted to reduce the amount by which their fees were allowed to increase. After 1975, physician fees under Medicare were prohibited from increasing beyond what the MEI allowed and physicians participating in Medicare were no longer allowed to bill Medicare patients for the difference between their charges and the Medicare allowed payment. In spite of these measures, the volume and intensity of services provided under Medicare continued to increase and costs continued to rise faster than Congress desired.

By 1980, with healthcare consuming 8.9% of the gross national product, President Reagan made a reduction in Medicare spending a priority for his administration. This was accomplished through a three-pronged approach. First, he set out to reduce the overall federal budget for Medicare. He then acted to restrict payments to providers of Medicare services. Finally, he instituted a policy of increased cost sharing for Medicare recipients[3].

In 1983, a prospective payment system for hospitals was intro-

duced using diagnosis related groups (DRGs) rather than retrospective costs to pay for hospital services. Payments were therefore fixed by diagnosis and detached from the expenses incurred by hospitals in providing care. This led to cost shifting, with non-Medicare patients charged more than Medicare patients to make up for losses, and a reduced willingness of hospitals to provide care for sick patients with complicated and expensive illnesses.

From 1984 to 1986 physician Medicare fees were frozen, initiating what then developed into a steady decline in physician income relative to inflation in the United States as private insurance payers joined forces with the federal government in reducing payment for physician services. The cost to Medicare for physician services, nevertheless, increased by 11.6% per year from 1984 to 1986 due to increased utilization[3].

In 1989, a Resource-Based Relative Value Scale (RBRVS) fee schedule was imposed on physician services for Medicare recipients, replacing the physician's usual and customary charges, thus limiting physician fees for services and the volume of services as well. At the same time, deductibles, co-pays, and Medicare premiums were increased[3].

The net result for physicians was a reduction in payment for services performed. Physicians participating in Medicare were paid the lesser of either the fee charged or the amount allowed by Medicare under its fee schedule. Participating physicians were also required to accept Medicare's allowed amount as full payment and were prohibited from billing the patient for any difference between the billed amount and the Medicare allowed amount.

The net result for hospitals was a reduction in payments for treatment of complicated patients. This was particularly troublesome for rural hospitals and inner city hospitals where Medicare and Medicaid recipients made up a sizeable portion of their patients. These hospi-

tals were unable to cost-shift and charge their private insured patients more to make up for the losses from Medicare and Medicaid. Unable to absorb the cuts in payments from Medicare and Medicaid, many of these hospitals were forced to close, reducing the access to care for rural and inner city populations.

The net result for Medicare recipients was an increase in their share of healthcare expenses and a rationing of benefits under Medicare as Medicare recipients became less attractive patients for both hospitals and physicians.

The net result for the federal government was the desired effect of reducing the rate of growth in Medicare expenditures. From 1980 to 1985, Medicare expenditures had risen by more than 16% per year. From 1986 to 1991, that rate dropped to 8.2% per year[3].

The reduction in the rate of Medicare expenditure growth had, however, largely occurred by shifting expenses to the private sources of healthcare funding. The resulting rise in the cost of insurance premiums for employers and employees led to widespread dissatisfaction with America's healthcare system, with 90% of Americans calling for healthcare reform. President Clinton, following his election in 1992, took the public's dissatisfaction as a mandate for the passage of a universal healthcare proposal. President Clinton, however, failed to distinguish the difference between dissatisfaction with the current system and support for a proposed change to the system. There was no clear consensus as to how the system should be changed but what did emerge as clear was that no one wanted the change to result in any reduction in benefits. Rolling the privately insured, uninsured, Medicare and Medicaid populations into a single system offered no way to provide universal coverage that was affordable without reducing benefits to at least some of the participants. The proposal to eliminate multiple insurers and administer the program through a single payer as a mechanism

to decrease administrative costs guaranteed that the insurance industry lobby would strongly oppose the plan. In a society accustomed to a plurality of choices and the right to independently pay for those choices, the provision in the Clinton plan to prohibit all care not allowed by the federal government was particularly distasteful. To prevent the class distinctions in healthcare that typified the European system of socialized medicine, the Clinton plan provided for fines **and** imprisonment for physicians who were compensated for providing care outside of that allowed under the government's program. With the medical community, the insurance industry, the AARP, and an increasingly large segment of the population expressing opposition to the Clinton plan for universal healthcare, the plan died in committee and proved a dismal and embarrassing failure for the Clinton administration.

Following the collapse of the Clinton plan for universal healthcare, concern again arose as to the government's ability to sustain Medicare funding. Medicare's trustees in 1995 predicted that the program would be insolvent by 2002 without either an increase in revenues or a decrease in expenditures[4]. This led to a sweeping package of reforms for Medicare in the 1997 Balanced Budget Act. Prominent among those reforms was outsourcing Medicare to the private insurers as Medicare Part C. Listed as Medicare Choice or Medicare Advantage plans, the private insurers were paid a set amount per Medicare enrollee in return for paying for all of the services required by that enrollee over the course of the year[5]. This combined Medicare Part A and Medicare Part B into a single benefit. The benefit to the enrollee is that it was all inclusive and thereby limited unexpected out-of-pocket expenses. The disadvantage to the enrollee is that they were limited to an HMO type network and the restrictions imposed by that network.

While Congress expected this measure to drastically reduce Medicare costs, the anticipated savings never materialized. Few Medicare

patients opted for these plans over traditional Medicare coverage. Further, the insurers enrolled only the healthiest Medicare patients into these plans, leaving the sickest, and costliest, patients to be funded by the federal government. As the payment structure for these plans assumed random enrollment, the government paid more to the insurers for the Medicare recipients enrolled in these plans than they would have paid for the services utilized outside of these plans. Hence, Medicare Part C actually served to increase, rather than decrease, Medicare expenditures through the 1990s[5].

Perhaps the most controversial feature of the 1997 Balanced Budget Act was the imposition of the Sustainable Growth Rate (SGR) Formula for setting the fee schedules for physicians under Medicare Part B. The purpose of the Sustainable Growth Formula was to set a target for physician payments under Medicare Part B that could not be exceeded. Prior to implementation of SGR, the fee schedule for physicians was set annually by the Medicare Economic Index. This index however did not serve to control the volume and intensity of the services provided by physicians and therefore did not allow Congress to set an annual budget for those services which could not be exceeded. SRG was intended to provide a remedy for that problem. Simply stated, the higher the volume of services provided to Medicare patients, the lower the fee schedule would be for those services under SGR[6]. This is clearly a mechanism for healthcare rationing for the elderly, with physicians being incentivized to contain the volume of services provided to the elderly and punished if they fail to do so. SRG has two essential flaws. First, it ties Medicare payment to growth in the Gross Domestic Product (GDP). From a budgetary standpoint this makes sense as tax revenues are closely tied to the GDP. However, the size and health needs of our elderly population are not tied to the GDP and do not fluctuate with changes in the GDP. Second, SRG fails

to account for the increasing longevity of our population and the consequent increase in consumption of healthcare resources per person.

From 1997 through the end of 2010, MEI would have allowed for a 32.1% increase in physician fees under Medicare. Actual increases in physician fee schedules have risen 19.6% in this 13 year period or 1.5% per year. Under SRG, had the formula been implemented, fees would actually have **declined** by 3.9% over the same 13 year period. However, as SRG has not been repealed and the reductions have only been postponed, Medicare fee schedules would need to be reduced nearly 30% as we draw near to the end of 2011 to comply with SRG. This takes into account a reversal of the 19.6% increase in fee schedule from 1997 through 2010, the 3.9% decline in reimbursement that should have occurred during this timeframe, and a 6.4% decrease in fee schedule for 2011 $(19.6 + 3.9 + 6.4 = 29.9)$[7].

Such a reduction in Medicare's physician fee schedules is unrealistic. First, relative to the 32.1% cost increases that physicians have incurred in their practices over the last 13 years, the 19.6% increase in fee schedules over that timeframe amounts to a 12.5% **decrease** in income over the same 13 years[7]. That, coupled with the various mechanisms for limiting payment to physicians since 1975, has already created a payment structure which is unrealistic. I've chosen the following example to illustrate this point.

As a neurologist, in order to take a proper history and perform a thorough exam, I allow 1 hour for each new patient. Medicare currently allows a participating provider a maximum of $152.16 for that 1 hour evaluation. If I allow 1 hour for lunch, I can do 7 such evaluations in an 8 hour day. Were I to work 5 days per week, 52 weeks per year (taking no vacations or time off for holidays) I could generate total revenue of $276,931.20. From this, I would have to pay $116,400 for rent leaving $160,531.20. Out of this, I need to pay my receptionist

to schedule appointments, my transcriptionist to prepare the reports on the patients I've seen, and another employee to bill Medicare and ensure that we are paid. Their current annual salaries total $144,620 or $48,206.67 per year per person. This now leaves $15,911.20. However, as an employer, I am also required to pay 7.65% of payroll for my portion of my employees' Social Security and Medicare tax. This amounts to $11,063.43 reducing the remaining income to $4,847.77. Yet, we're still not done with taxes. The State of Minnesota, where I practice and because doctors are rich, charges physicians 2% of the gross practice revenue to fund the state's program for the uninsured who are less fortunate than us "rich doctors" but who earn too much to qualify for Medicaid. 2% of $276,931.20 is $5,538.62. Subtracting this payment leaves me owing the State of Minnesota $690.85 at the end of the year. Yet, we're still not done with taxes. Because all employers are wealthy, it is the responsibility of employers to fund the endless extensions of unemployment insurance to provide for those who lost their jobs as a consequence of the bureaucratic bungling that created the Great Recession. The unemployment insurance is provided by a tax levied exclusively on employers and that tax has risen over 400% since 2007. My unemployment tax is currently 9% of the first $28,000 earned by each of my employees. This amounts to another $2,520 per employee or another $7,560 that I owe the State of Minnesota, bringing the amount owed to $8,250.85. The State of Minnesota will then reward my efforts at trying to work within the economic constraints of Medicare and serve the healthcare needs of Minnesotans by assessing a 25% penalty to the $8,250.85 in unpaid taxes, adding another $2,062.71 to the tax owed or $10,313.56 for the year. The state will initially levy my practice bank account to collect its taxes. If unable to do so, it will then file a levy against any personal assets that I may possess. Ironically, while this debt is largely due to Minnesota's tax on

physicians to provide insurance for the uninsured, my employees are uninsured because I have no funds with which to purchase insurance on their behalf and their earnings are too high to qualify for the state's program for the uninsured.

The state would, in reality, argue that I am paying my employees too much and that I could manage if I trimmed my expenses. After all, the average income in the private sector is $35,000 per year and my employee's are being paid a wage 37% above that figure at $48,000 per year. This is again ironic, coming from an employee of the state government. The average public employee income in Minnesota is $55,826 per year, 16% above the figure that I pay my employees. Furthermore, the taxes from my practice and the taxes on the income of my employees fund the very generous salaries and pensions for these government employees, while I lack the means to provide a retirement program for my employees or for myself. With the meager income my employees are receiving, it is doubtful that they can adequately fund their own retirements. As for me, I do not yet have an income under this compensation system structured by the federal government. I need to address my day to day needs and can't even fathom concerning myself with retirement.

In a capitalist economy, the government exists to serve the needs of its population and, in such an economy, I would be free to adjust my charges to allow for the generation of profit. In a socialist economy, the population exists to serve the needs of the government. We are all but enslaved. Svetlana Kunin, a Russian immigrant to the United States, expressed this well in an editorial written for Investor's Business Daily on 12/19/2011.

"The question of a fair approach to taxation in totalitarian socialism can be simple. What is the minimal cost of living?

The socialist answer can be found in the old Soviet joke: 'The minimal cost of living is the minimum needed for people to live on, so that the government can be comfortable.' Whether talented or mediocre, proletariat or professionals, all were equally poor, while top government officials had special housing, stores and medical facilities allocated just for them. Education does not lead to a prosperous society if people are not free to pursue their interests.

The USSR lasted from 1917 to 1987. Despite the Russian population being very well educated and everyone paying whatever government found to be 'fair share' of their salaries, by 1987 the centrally managed economy was collapsing.

So what is it that drove American progress if, in the words of Obama, the free market 'doesn't work. It's never worked'? Was America's standard of living achieved due to individuals using their own capacities, in their own pursuits for happiness or success, unhindered by government control? Or was it thanks to government bureaucrats drawing up plans and managing the economy?

American progressives remind me of the top echelon of Soviet Communists: so confident in their condescension to people outside their circle, so in love with their rhetoric about fairness and the welfare of the masses, and so indifferent to the real fate of individual human beings."[8]

I grew up in the Cold War in which the United States, as the champion of capitalism, defied the aggressive expansion of Soviet communism. It saddens me to see how close we are to becoming what we fought so hard to defeat.

While the scenario above is discouraging, the list of expenses is not yet finished. I am required to carry professional liability (malpractice) insurance in order to maintain hospital privileges, costing another $15,000 per year. I am also required to carry worker's compensation insurance, another $3,200 per year. Both the state and federal governments require me to bill electronically. I therefore need internet access and have to pay electronic clearing houses to handle the billing. These cost another $4,134 per year. My accountant costs another $5,200 per year to prepare the quarterly and annual returns required by the state and federal governments. Providing my office with a telephone costs another $4,200 per year. If I am going to attract 7 new patients per day, I will need to advertise and this will cost at least $16,000 per year. In order to maintain my license, I am required to attend continuing education classes at a cost of another $5,000 per year. I will need stationery on which to have my reports typed as well as other office supplies conservatively averaging $40,000 per year. Postage to mail reports to my referral sources will cost another $6,000 per year. Clean gowns for my patients and sheets for the exam table will cost another $9,000 per year. Hopefully, I will never need an attorney because clearly I cannot afford one. To remain in practice, I will need another $107,734 per year. Add the $8,250.85 in unpaid taxes noted above, without the penalty imposed for not having paid them, and the figure needed to remain in practice grows to $115,984.85.

Fortunately, I still have weekends that I can work to provide that income and the new patients that I am seeing during the week will need follow up care that can be provided on those weekends. Of course, I

will need to hire another receptionist to work the weekends and this will cost another $19,200 per year. Matching FICA contributions will increase this by $1,392 to $20,592. I will therefore now need to generate $136,576.85 to cover the additional expense.

Seeing a follow up patient every 15 minutes and seeing these patients for 7 hours in an 8 hour day means that I can see 28 patients per day or 56 patients per weekend. Medicare allows a participating provider $67.02 for each of these follow up visits. This means that I can earn $3,753.12 per weekend or another $195,162.24 per year. Of course, the state of Minnesota will tax that income 2% for another $3,903.25 in provider tax. The states unemployment tax will also cost me another $1,728.00 for the wages paid to my weekend employee. Subtracting these, leaves the earnings from the weekend work at $189,530.99. Subtracting the $136,576.85 in expenses noted above, I now have a profit of $52,954.14. However, if I now purchase health insurance for myself and my employees with a $2500 deductible per person and $5200 deductible per family, this will cost another $48,000 per year. Subtracting this, I can now pay myself an annual salary of $4,954.14 for the privilege of working 8 hours per day, 7 days per week, and 365 days per year. That is, however, unless I am unable to fill every appointment or someone misses an appointment because these numbers assume perfection.

"Whether talented or mediocre, proletariat or professionals, all were equally poor."[8]

Under Medicare and socialized medicine, we do appear to be arriving at the American version of Soviet Communism. I would argue that our federal government is, in essence, enslaving our country's physicians were it not for the fact that no physician could feed or house himself on $4,954.14 per year. Even slaves were housed and fed.

I suspect that this scenario exists because the vast majority of our elected officials have never run a business. With earnings of almost $475,000 from evaluation and treatment of Medicare beneficiaries, I would clearly be viewed by our politicians as a rich doctor. Having not run a business, our leaders have no concept of how much it costs to do so. In reality, the only way Medicare works is by offsetting the losses from inadequate Medicare payments with less inadequate payments from private insurers.

A healthy company within any service industry requires a 50% profit margin. The profit margin in the scenario outlined above is 1.1%. With about $450,000 per year of expenses, I would require an annual income of $900,000 to produce a 50% profit margin. This would require payment of $535 per hour assuming an 8 hour work day, 5days per week and 48 weeks per year. This would require payment for initial evaluations to increase from $152.16 to $535 and follow up visits to increase from $67.02 to $133.75.

Instead of implementing increases in physician fee schedules to make compensation reasonable (and, by the way, put physician hourly rates at par with attorney hourly rates), the attorneys who comprise the majority of our elected officials expect to mollify the medical community by agreeing to prevent the 30% decrease in physician compensation called for under SRG. Were Congress to implement SRG and reduce physician fee schedules by another 30%, the losses would overwhelm the ability of most physicians to offset those losses with payments from other sources. Most physicians would abandon enrollment in Medicare as participating providers and Medicare would consequently cease to exist. As our politicians lack the will to face the consequences that would follow a collapse of Medicare, it is my opinion that SRG will never be implemented. Nor will needed increases in physician fee schedules be allowed. SRG, however, is

also not likely to be repealed as too many of the Congressional Budget Office's projections of cost savings are based on SRG. The illusion of those cost savings added to the current inadequate compensation structure under Medicare do, in fact, now represent a good part of what makes the Affordable Care Act affordable.

The Medicare Prescription Drug, Improvement, and Modernization Act of 2003 established Medicare Part D as the prescription drug plan for Medicare. Under Medicare Part D, enrollment is either in a private drug plan with traditional Medicare Part A and Part B coverage or enrollment is in a Medicare Advantage Plan (replacing Medicare Part C) which operates as an HMO providing all services under Medicare Part A, Part B and Part D. Each plan is free to choose what drugs are covered under its formulary. Enrollees in a drug plan are obligated to remain with the plan for a period of one year, though the drug plan is allowed to change the drugs it covers during the year. Non-formulary drugs are not covered. The Medicare Act stipulated that the private drug plan include a $250 deductible, a 25% cost-sharing on formulary drugs from $251-$2,250. After $2,250, the Medicare beneficiary falls into what has been termed the "doughnut hole" until another $3,600 has been spent on drugs allowed under the plan's formula. This $3,600 is an out-of-pocket expense incurred by the Medicare beneficiary. Once allowed drug costs reach $5,100 in a calendar year, Medicare begins drug coverage again with a 5% co-payment from the Medicare beneficiary[9].

The 2003 Medicare Act also made changes to the deductible and premiums for Medicare Part B. The deductible, which had been fixed at $100 since 1991, was increased to $110 in 2005 and scheduled to increase yearly thereafter. For the first time since Medicare's inception, Part B premiums were indexed to income. Starting in 2007, individuals with incomes between $80,000and $100,000 per year and

couples with incomes between $160,000 and $200,000 per year paid 35% of the Part B rate. Individuals with incomes between $100,000 and $150,000 per year and couples with income between $200,000 and $300,000 per year paid 50% of the rate. Individuals with income over $200,000 and couples with income over $400,000 paid 80% of the rate[9].

Medicare Part D added nearly $50 billion in federal Medicare expenditures in 2006. These expenditures were projected to grow by about 9% per year to $73 billion by 2010. The Congressional Budget Office in 2011 calculated actual costs in 2010 to have been about $52 billion and estimates that costs between 2007 and 2013 will be 23% below expectation producing a "savings" of $123 billion over the period[10].

The relative stability in Part D expenditures is unprecedented in government run programs and has consequently sparked debate over the reasons for that stability. The Congressional Budget Office (CBO) has, in fact, conducted a detailed review of the factors contributing to the stability in expenditures under Part D and has published their findings in their report, "The Budget and Economic Outlook: Fiscal Years 2008 to 2017." In their report, they cite free market competition as one of the factors leading to price stability noting that bids from drug plans to provide coverage for 2007 were lower than expected, about 15% below Medicare's projected per-capita costs. The competitive process thus accounted for the majority of the price stability.

Another factor cited is that participation has been lower than expected. The CBO had anticipated that 93% of Medicare enrollees would participate in Part D. Only 77% actually chose to do so. In evaluating why enrollment was below expectation, data from the Centers for Medicare and Medicaid Services showed that a larger than expected number of Medicare beneficiaries already had prescription coverage comparable to Part D. In addition, the "doughnut hole" may

have contributed to the decision of many seniors to remain with their private plans and forego participation in Part D. In recognition of this, the CBO lowered its participation estimates for Medicare recipients in Part D to 78% through 2017.

The "doughnut hole" may also have served to control prescription drug spending by seniors between 2006 and 2010. Knowing that they would be responsible for $3,600 in prescription costs after the first $2,400 in a calendar year, many seniors may have opted for less expensive generic alternatives over more expensive brand-name drugs. A more sinister interpretation, however, is that they were never allowed the choice. Drug plans bidding for contracts with Medicare are free to develop their own formularies. Excluding more costly brand-name drugs from those formularies, especially those for which there is no generic equivalent, may have been a basis by which the plans were able to offer bids below Medicare's expectations. This certainly makes the provision of drugs cheaper, but does it do so by sacrificing quality over cost?

Data shows that prescription drug spending in 2010 was 35% lower for all healthcare consumers in the United States than was projected in 2003[10]. This is not because Americans consumed 35% fewer drugs. It is directly related to a coordinated effort on the part of private managed-care insurers to mandate generic drug usage. This has been accomplished in a variety of ways. Tiered co-payments have been erected to steer patients toward cheaper alternatives by providing lower co-pays for preferred choices and higher co-pays for more costly alternatives. Where a generic drug exists, some plans will provide no coverage for the brand-name version of the same drug. The consumer is not even given the option of paying the difference between the cost of the brand-name and the cost of the generic. If the consumer wants the brand-name, he/she must pay the full price. Managed-care's posi-

tion is that brand name and generic drugs are equivalent and there therefore exists no reason to use a brand name in place of a generic.

This, however, is not entirely true. The chemical composition of the brand name and generic drugs is equivalent but that cannot necessarily be said for their effectiveness. This is because the brand-name drug and the generic substitute may have differences in their bioavailability. The bioavailability of a drug is a determination of how much of the drug enters the bloodstream and affects its target organ(s) per a given dose. The FDA allows a variance of 25% in bioavailability between a generic drug and its brand-name counterpart. Thus, if a consumer purchases a generic drug from his/her pharmacy from a manufacturer whose drug has a bioavailability that is 25% **greater** than the brand-name equivalent and the very next month purchases the very same generic drug from his/her pharmacy but this time from a manufacturer whose drug has a bioavailability that is 25% **less** than the brand name equivalent, the very first dose of that drug will produce a potential 50% decrease in the blood level of the drug and a major drop in effectiveness. With many drugs this may not be meaningful but, in other cases, the difference can be catastrophic. With drugs such as anticonvulsants used to treat seizure disorders, the change can be enough to precipitate a seizure in an otherwise stable patient and endanger that patient's life. For this reason, the American Academy of Neurology has maintained a longstanding position that generics should never be used in the treatment of seizure disorders. Not all health plans, however, will honor that position.

Plans are now even mandating substitution of drugs within a treatment class if a generic exists within the treatment class but there is no generic substitute for the actual drug being used. To explain, I will provide another example. I manage a number of chronic pain patients. Because these patients have severe pain from conditions for which

there is no effective resolution, their pain is managed with narcotics. To minimize abuse and habituation, it is the standard of care to use extended release narcotics to address the bulk of the pain, with immediate release narcotics used in limited quantities for episodes in which the pain is not adequately addressed by the extended release narcotic (breakthrough pain). There are only two generic extended release narcotics available today. These are morphine sulfate extended release and fentanyl patches. OxyContin, which is an extended release formulation of oxycodone, has no generic but is in the same treatment class as morphine sulfate extended release. They are both class 2 narcotics. Because these drugs are in the same treatment class, I have patients whose OxyContin prescription has been denied until they have tried and failed morphine sulfate extended release. These are not identical drugs. They have different chemical structures, different allergy profiles, different tolerance profiles and different response profiles. There exists no medical or scientific basis for mandating this kind of substitution. Yet, in the name of cost savings, this kind of mandate is becoming increasingly more common.

These mandates for generic drug usage represent simply another form of healthcare rationing designed specifically for the prescription drug market and this is having a chilling effect on the research and development of new drugs in the United States. Pharmaceutical innovation peaked in the 1990s with the introduction of numerous "blockbuster" drugs to more effectively treat a variety of diseases. In a market free from impediment, newer more effective drugs easily supplanted older less effective drugs. Pharmaceutical companies recouped their investments and were rewarded with profits for their innovation. The combined efforts of the federal government and private insurance plans to mandate generics from 2000 to present have served to alter that market. Unable to recoup their research and development costs,

pharmaceutical companies have slowed innovation and the production of new drugs in the United States has consequently declined. Yes, this may make prescription drugs more affordable but at what cost to the long term health of our population?

Rationing in healthcare, while still insidious, is becoming increasingly more overt. In 2005, Congress initiated a pilot program to address concerns about fraud and abuse within the Medicare system. Before proceeding, it is necessary to define these terms. Fraud is any act of intentional deceit. Demonstration of intent to deceive is critical. Thus, billing Medicare for the treatment of 45 patients in a day when only 25 were seen would constitute an example of fraud. Abuse is far less clear. Numerical codes are used to define the type of service being billed to all insurers, including Medicare. To bill the one hour initial evaluation described earlier in this chapter, I used the code 99204 which is the code for an extensive initial patient evaluation. I could have used the code 99205 for a comprehensive initial evaluation which pays more—$189.81 rather than $152.16. The difference between the codes is determined by the complexity of the evaluation and that determination is subjective. Therefore, had I used the code 99205 and were the government to conduct an audit and not agree that the complexity warranted that code, I would be accused of up-coding, a form of abuse.

The frequency with which patients are seen in follow up is also discretionary. Should follow up visits be done weekly, bimonthly, monthly, quarterly, semi-annually or annually? As you might suspect, there is no one correct answer. The frequency of follow up is patient specific, determined by the particular needs and circumstances of each patient. Nonetheless, should an auditor disagree with the frequency with which I have seen patients in follow up, I can be charged with abuse.

Laws exist which prohibit physicians from referring patients to diagnostic testing facilities in which they have a less than complete

ownership interest. The concern of Congress is that physicians, with a financial motivation to refer patients to a given diagnostic facility, would direct their patients to that facility over facilities which might be more cost-effective and would also be motivated to order unnecessary tests to increase their profits from such facilities. Referrals to treatment centers such as physical therapy programs, dialysis units, or surgical centers in which the provider has a less than complete ownership interest are prohibited for the same reasons. Receipt of referral fees (kickbacks) from facilities in which a healthcare provider has no financial interest is prohibited for the same reasons. Violation of these laws would be prosecuted under the rules governing fraud.

If, however, a group of physicians wholly owns a diagnostic testing center, physical therapy program, or surgical center, those facilities can be used by that group of physicians as those centers are part of their practice. There is no violation of laws against self-referral as a referral, by definition, is to an entity outside the scope of an individual's or group's practice.

The extent to which a group of physicians uses their diagnostic or treatment facilities can, however, be viewed as abuse. The need for any given diagnostic test is subjective. The duration and intensity of physical therapy sessions is also subjective. The absolute need for a surgical procedure can be subjective. A reviewer from a government agency or insurance company can disagree with need for any diagnostic or treatment regimen, ascribe the utilization of diagnostic tests or treatment procedures to a motivation to increase the group's profit and allege abuse. Ironically, Medicare's payment structure is set up to encourage abuse of diagnostic testing and treatment procedures. Because Medicare pays so little for patient evaluations, these procedures can help to make those evaluations profitable. Knowing this, investigators for Medicare automatically consider utilization of

diagnostic testing and treatment procedures to be suspect. Perhaps if the funds currently devoted to investigation of suspected abuse were used instead to make more appropriate payment for initial and follow up evaluations, the cases of actual abuse of diagnostic testing and treatment procedures would decline.

Relationships between doctors and pharmaceutical and medical device companies are being scrutinized with increasing frequency for evidence of fraud. Pharmaceutical and device manufacturers are required by the Food and Drug Administration (FDA) to conduct clinical trials of their products before (pre-market trials) and after (post-market trials) drugs and devices are approved by the FDA for use, in order to demonstrate safety and efficacy. These trials require doctors to participate in the studies and it is expected and legal for those doctors to be compensated by the pharmaceutical and device companies for their time and expertise, as long as that compensation is appropriate for the time and expertise. Once again, however, the extent to which the compensation is appropriate is subjective. This subjectivity is particularly true in post-marketing studies where a doctor can be accused of using a particular new drug or medical device to the exclusion of less costly alternatives for the sole purpose of augmenting his/her income. Such allegations of fraud and the subsequent investigation, which may require the doctor to hire legal counsel, can consume a great deal of a physician's time and resources for which he/she is not compensated. As such investigations are becoming increasingly more common, they are producing a chilling effect on the willingness of doctors to participate in these studies, adding to the difficulty in bringing new drugs and medical devices to the market.

The very necessity of a specific medical or surgical treatment for a specific medical condition can be a basis for allegations of abuse. An example would be useful here. A 56 year-old man presents to a hos-

pital emergency room with a complaint of chest pain that started 30 minutes earlier. His blood pressure is slightly elevated but his physical exam is otherwise normal. An electrocardiogram (EKG) is performed and is also normal. Cardiac enzymes are drawn and the initial creatine kinase (CK) level is normal. An antacid is given orally followed by a slight decrease in chest pain. Oral nitroglycerin is given also followed by a decrease in chest pain. What does the emergency physician do? Does he/she admit the patient for overnight observation in the coronary care unit or send him home with a diagnosis of heartburn? The correct answer per my medical training is to admit the patient for observation. The EKG and CK level may not show any abnormality for 24 hours. Consequently, if this man is suffering a heart attack, he may die if sent home. However, if in the next day there are no changes on the EKG and if the CK level remains normal, the hospitalization could be viewed as having been not medically necessary. Thirty or forty such "not medically necessary" hospitalizations over the course of a year could be considered a pattern of abuse. I assure you that I am not being paranoid here. Institutions such as the Rand Corporation have published studies with just such conclusions. One study, focusing on abuse of laboratory tests, noted that 50% of complete blood counts (CBC) and EKGs were normal and therefore concluded that 50% were not medically necessary. Addressing such "abuse" was recommended as a means of decreasing the cost of healthcare.

Back pain is an extremely common symptom and treatment of back pain in the United States costs over $50 billion per year. There is, however, no one-size-fits-all treatment approach for back pain; nor should one exist. There are a multitude of potential causes for back pain and evaluation and treatment should therefore be individualized. This creates fertile ground for allegations of abuse. Was a course of physical therapy medically necessary before obtaining an MRI of the lumbar

spine? Was the MRI of the lumbar spine necessary before beginning a course of physical therapy? If physical therapy is performed, how long is long enough? How long is too long? What modalities should have been used in the course of therapy and were not? Should epidural injections have been performed? Should facet blocks have been performed? Should nerve root ablations have been performed? If surgery was performed and was not successful, should the surgery have been performed? Often the answer to these questions is not black and white. In an audit of services, however, the answer has to be either yes or no; there is no room for maybe. The motivation of the auditor is therefore critical.

Congress authorized a pilot program in 2005 employing private organizations, Recovery Audit Contractors (RAC), to perform the fraud and abuse audits. These contractors were tasked with auditing hospitals, skilled nursing facilities, physician practices, laboratories, and durable medical equipment companies to determine overpayments and underpayments by Medicare. The RACs are paid a percentage of the overpayment and underpayment amounts. While the RACs are ostensibly neutral in their determination of overpayments and under-payments, the operative word in their name is recovery. Consequently, given the interest of the federal government in recovering overpay-ments, one would expect that these contractors would exhibit some bias in their determinations. If so, one's expectations would not be disappointed. Of the improper payments reported from March of 2005 to March of 2008, 96% were overpayments resulting in a return of $992.7 million from healthcare providers to the federal government[11].

The Tax Relief and Health Care Act of 2006 made the Recovery Audit Contractor program permanent and this program is now active in all 50 states11. President Obama in 2009 further tasked the RACs with recovery of $50 billion in "improper" Medicare spending[12]. While less than $1 billion was recovered in the 3 years from 2005-2008, $17.6

billion was recovered in 2011 alone[12]. I believe it is a safe conclusion that the majority of these recoveries surrounded allegations of "abuse" that most healthcare providers could not afford the cost of defending. In this system, the physician or other healthcare provider is guilty until he can prove himself innocent.

Prepayment reviews of Medicare claims by Recovery Audit Contractors are set to begin in 2012[12], providing an even more effective mechanism for rationing healthcare within the Medicare system. Doctors and other healthcare providers will be further intimidated or otherwise "encouraged" to ration care so that the patients' anger can be directed toward their healthcare providers rather than at the government and the health plans that control the rationing.

The decision to accelerate recovery efforts in 2011 is very likely tied to the increase in anticipated expenditures. In 2011, the first of the baby boomers turned 65 and entered the roles of Medicare. The baby boomers are the children born to the 16 million veterans returning home from World War II. This is a population of 78 million born between 1946 and 1964. Thus for the next 18 years, from 2011 to 2030, Medicare will be enrolling over 10,000 new members per calendar day. The Medicare trustees consequently anticipate 80 million enrollees in Medicare by 2030, double the 39.6 million enrolled in 2010. Compounding the problem is the decline in birth rate that has taken place since 1964. According to the Kaiser Family Foundation, we currently have 3.4 workers paying taxes to support Medicare for each retiree. By 2030, when the retired population has doubled, the worker-to-retiree ratio will concurrently drop by one-third to 2.3[13]. Without any medical inflation at all, the Medicare tax would have to triple from 1.45% per employee to 4.35% in order to maintain coverage as it exists today. This, however, would also require an identical increase in the employer's matching contribution and, for the self-

employed, this means an 8.7% tax. Though beyond the scope of this book, the Social Security Program would have the same funding problem as Medicare. Tripling the Social Security tax from 6.2% per employee would create an 18.6% tax per employee with a matching employer contribution. This means that each employee loses 22.95% of his/her income before deductions for federal and state tax are even considered. Even worse, each employer would need to pay a 22.95% tax on the wages of each of his/her employees. Those unfortunate self-employed individuals would be paying 41.55% of their income toward Medicare and Social Security taxes alone before the rest of their income is drained by federal and state income taxes.

The effect of tax increases of this magnitude would be devastating. The unemployment rate would likely exceed 25% as large employers would reduce their U.S. workforce and shift employment abroad to avoid the payroll taxes here. Small businesses, unable to fund the mandatory matching Social Security and Medicare taxes and unable to shift employment abroad, would fail on a massive scale, adding to the ranks of the unemployed. No good deed left unpunished, those companies struggling to remain alive in this environment would then be further crippled by massive hikes in their unemployment tax, eventually dooming even the most frugal and well-intentioned companies.

Lest I be accused of groundless fear-mongering, the following is from page 29 of the 2009 annual Medicare trustee report:

"The long-range financial projections for HI continue to show a substantial financial imbalance. The HI actuarial deficit in this year's report is 3.88 percent of taxable payroll."[14]

HI is hospital insurance better known by most of us as Medicare Part A, the portion of Medicare directly funded at present by a 1.45% tax on payroll with a matching employer contribution. Add 3.88 to the current 1.45% of taxable payroll and the Medicare tax rate would be 5.33% per employee, a number larger than the one that I have used above because the trustees have actually factored inflation into the equation. Alternatively, without the increase in taxes or a decrease in benefits, they project a Medicare expenditure deficit of $45.8 trillion by 2085[15].

The use of Recovery Audit Contractors is only one of the tools being used to ration healthcare in an effort to avoid the financial calamity resulting from 45 years of socialism. The Patient Protection and Affordable Care Act of 2010, while advertised as a program to provide healthcare to the uninsured that are not eligible for Medicaid, is more about decreasing Medicare expenditures, socializing all of healthcare, and increasing revenues than it is about extending healthcare to the uninsured. Effective January 1, 2013 there will be an additional Medicare tax of 0.9% on the income of individuals earning $200,000 or more per year[16]. In addition, these individuals will pay a 3.8% tax on the lesser of net investment income or the amount by which their adjusted gross income exceeds $200,000[16]. These additional taxes are projected to bring in $210.2 billion over 10 years. The Patient Protection and Affordable Care Act will also impose an annual fee on health insurance providers[17] raising an estimated $60 billion over 10 years and, in the process, make insurance less affordable for employers and their employees as this fee is passed through in the form of higher premiums. In 2018 it will impose a 40% excise tax on "Cadillac" health plans[18], with these plans defined as premiums in excess of $10,200 per individual or $27,500 per family. At age 61, my annual premium now, with no illnesses and healthcare utilization below $500 per year,

is $11,880 per year with a $2,500 annual deductible. This is hardly a "Cadillac" plan but, under the terms of the Affordable Care Act, would nevertheless be subject to a 40% tax. With private plans becoming 40% more costly, the only alternative is the federal government's plan. Thus, we fully socialize all medical care by default.

Why, you ask, would the federal government want to socialize all of healthcare when their projections clearly demonstrate that they cannot afford the cost of Medicare alone? The answer to that question lies in how they intend to make Medicare affordable. The Patient Protection and Affordable Care Act is an exemplary instance of socialistic euphemism. It neither protects patients nor makes healthcare affordable, but doesn't it sound good?

The extent to which it is inimical to the best-interest of patients lies in its provision for the establishment of an Independent Payment Advisory Board (IPAB) to replace the Medicare Payment Advisory Commission. The explicit task of the IPAB is to reduce the rate of growth within Medicare. The board is comprised of fifteen unelected members appointed by the President who will determine Medicare reimbursement. The Chief Actuary of the Centers for Medicare and Medicaid Services will advise the IPAB of the projected per capita growth rate for Medicare. If the projection exceeds a target growth rate, the IPAB must produce a proposal to reduce per capita Medicare spending. The Secretary of Health and Human Services must then enact the proposal of the IPAB unless prevented from doing so by Congress. This is a dramatic departure from the current system in which the Medicare Payment Advisory Commission plays an advisory role to Congress but cannot enact any proposal without congressional approval. As we know, Congress can be slow in agreeing to approve anything.

Congress, however, can be equally slow in agreeing to block anything. The only way to block implementation of an IPAB proposal is

through majority vote in the House of Representatives and a three-fifths supermajority in the Senate. Furthermore, the Patient Protection and Affordable Care Act prohibits Congress from blocking enactment of the IPAB proposals unless Congress agrees on an equally effective alternative and passes the alternative provision by August 15th. The Patient Protection and Affordable Care Act consequently grants virtual dictatorial power to the IPAB in its determination of Medicare reimbursement. Were healthcare to be fully socialized, it would extend that dictatorial power to all healthcare reimbursement.

The Patient Protection and Affordable Care Act prohibits the IPAB from making recommendations to ration healthcare, raise taxes, increase premiums for Medicare beneficiaries, restrict benefits, increase cost-sharing (i.e. deductibles, co-pays, etc.) or modify eligibility. Consequently, the IPAB has little authority to fulfill its mission by doing anything other than reducing reimbursement to healthcare providers. Furthermore, payment reductions to clinical laboratories are prohibited until 2016 and cuts to hospitals and hospices are prohibited until 2020. Until then, the focus will be on reducing payments to physicians, especially specialists, and the Medicare Advantage (HMO) programs. Over the next 10 years, according to the Kaiser Family Foundation 2011 "Medicare Spending and Financing" report, the projected savings from reduced physician reimbursement are $157 billion and the projected savings from Medicare Advantage reductions total $206 billion[19].

The IPAB is to produce its first report by 2014 and implement its first proposals in 2015. It is likely that the leading recommendation will be an elimination of fee-for-service payment and movement toward pay-for-performance packages and the use of Accountable Care Organizations. This would address concerns raised in the 2011 Medicare trustees' annual report:

"It is important to note, however, that the substantially improved results for HI and SMI Part B depend in part on the long-range feasibility of the various cost-saving measures in the Affordable Care Act—in particular, the lower increases in Medicare payment rates to most categories of health care providers. Without fundamental change in the current delivery system, these adjustments would not be viable indefinitely. Under current law, the annual increase in Medicare prices for most health services will be reduced by about 1.1 percentage points (the estimated growth in economy-wide multifactor productivity) below the increase in prices that providers must pay to purchase the goods and services they need to provide health care services. Over time, unless providers could alter their use of goods and services to reduce their cost per service correspondingly, the prices paid by Medicare for health services would fall increasingly below such costs and providers would eventually become unwilling or unable to treat Medicare beneficiaries.

For Example, if future improvements in provider productivity remained similar to what has been achieved in the recent past, then Medicare payment levels for inpatient hospital services at the end of the long-range projection period would be only about one-third of the corresponding level paid by private health insurance (assuming that private payer rate increases follow historic patterns of growth, independent of Medicare or other health system changes). In this case, the lower Medicare payment rates would result in negative total facility margins for an esti-

mated 15 percent of hospitals, skilled nursing facilities, and home health agencies by 2019, and this percentage would reach roughly 25 percent in 2030 and 40 percent by 2050. Providers could not sustain continuing negative margins and would have to withdraw from providing services to Medicare beneficiaries, merge with other provider groups, or shift substantial portions of Medicare costs to their non-Medicare, non-Medicaid payers.

*In addition, projected Part B expenditures for physician services are very likely to be substantially understated. Under current law, the SRG system requires a reduction in January 2012 of almost 30 percent in the physician fee schedule, which, on average, currently sets fees which are significantly below those for private health insurance. If the rate of growth of private payments were not affected by continued implementation of the SGR, Medicare physician payments would be less than **40** percent of the corresponding private health insurance prices within **20** years and, by the end of the 75-year period, would be only about **25** percent of private insurance levels. If such payment differentials were allowed to occur, Medicare beneficiaries would almost certainly face increasingly severe problems with access to physician services."* [20]

Changing the payment structure for providers of healthcare from fee-for-service to pay-for-performance or Accountable Care Organizations would make comparison between Medicare payments and payments from private insurers more difficult, at least in the short run. Make no mistake, however, the object is to decrease what the federal government

pays for healthcare services so that tax dollars from a dwindling work-force can still sustain the medical needs of a rapidly expanding retired population. There is no way to do this without diminishing the income of healthcare providers. As noted by the Medicare trustees, the growing disparity between Medicare payments to hospitals, skilled nursing facilities and physicians would eventually result in fewer and fewer providers participating in Medicare. This would either threaten the reduction in payment structure or result in the dissolution of Medicare due to lack of provider participation. That is, however, unless alternatives for healthcare providers no longer exist. Socialization of all healthcare into a single system controlled by the federal government would eliminate alternatives for healthcare providers. They would either participate in the system or cease to deliver healthcare.

Eliminating alternatives to a federally run single-payer healthcare system would ensure that healthcare providers would not abandon the system but would still not ensure that quality healthcare can be delivered to an entire population within the defined cost restraints. Even with implementation of the various cost-saving and revenue enhancing measures contained within the Patient Protection and Affordable Care Act, the Medicare trustees in their 2011 report on page 228 still project a 75-year budget deficit of $33.8 trillion. The value to the federal government in pay-for-performance packages is that they shift the problem of allocating insufficient resources from the government to providers of healthcare. Defined payments under pay-for performance can be made to healthcare providers for any specific diagnostic category. Healthcare providers are then left with the decision as to how those resources are to be used to provide treatment to individuals within that diagnostic category. While this sounds viable in theory, I fear that continued and accelerating financial pressures will not allow this to remain viable in practice. As with most govern-

ment programs, if surpluses exist at the end of the year, the budget for that diagnostic category will be reduced. This will continue until funding becomes inadequate to provide for both quality care and reasonable reimbursement for services, forcing healthcare providers to choose between using limited resources to provide care or to remain in business. Inadequate funding can only result in inadequate treatment but, under this system, the perception is that the healthcare provider, not the government, is responsible for rationing care.

Anyone who doubts that healthcare will be severely rationed under a socialized program in the United States has entirely lost touch with reality. The U.S. government currently takes in $2 trillion in revenues and spends $4 trillion annually without yet incurring any of the costs associated with the increase in entitlement created under the Patient Protection and Affordable Care Act. The federal government is already over $16 trillion in debt and has no viable plan for reducing the debt. One of the recommendations from the "supercommittee" tasked with reducing the deficit by $1.2 trillion was the elimination of the employer tax deduction for employee health insurance premiums. That action would unquestionably result in employers universally abandoning health insurance payments for their employees, hastening implementation of the scenario outlined above. The shift from employer-based healthcare to the government's program would add, at a minimum, another $2 trillion in federal spending. That spending would have to be covered by a combination of higher taxes, premiums charged to individuals by the federal government, and reduced healthcare expenditures—i.e. rationing. There is a reason why members of the U.S. Congress have exempted themselves from inclusion in what has widely come to be known as "ObamaCare."

These same members of the U.S. Congress, while avoiding the consequences of healthcare rationing in the system they have created,

can continue their rhetoric about how they are looking after the welfare of the masses with their hands unstained by damage their policies have wrought. Under pay-for-performance, they can simply blame greedy doctors and hospitals for providing inadequate care with the resources allotted to them. As Svetlana Kunin put it:

> *"American progressives remind me of the top echelon of Soviet Communists: so confident in their condescension to people outside their circle, so in love with their rhetoric about fairness and the welfare of the masses, and so indifferent to the fate of real human beings."* [8]

The problem with socialism is that sooner or later you really do run out of other people's money. Of course, we can always tax the rich to enable the system to continue. After all, those who have more have an obligation to pay more, don't they? Before walking through that door, however, consider the following. According to the Internal Revenue Service, the top 1% of earners in the U.S. already pay 37% of the taxes[21]. This percentage is already comparable to the socialist countries in Europe whose economies are in such a state of disrepair. With expiration of the Bush tax cuts, the top federal income tax rate returns to 38%. To this must now be added the existing 1.45% Medicare tax and the additional 4.7% tax on individuals earning $200,000 or more called for under the Patient Protection and Affordable Care Act. This brings the top federal income tax rate to 44.15% before state income taxes are even considered.

Still this may not dissuade one from supporting the argument that we should add another 5% tax on the income of the top 1%. So what if they pay 49.15% of their income in federal income tax. They're rich enough to still have plenty of money left after taxes. That was, in fact, the argument used by President Taft in 1913 when seeking ratification

of the 16th amendment to the U.S. Constitution allowing the federal government to collect income tax. The majority of the tax then, as now, was only to be levied on the top 1%. Those earning $3,000 or more per year would pay a federal tax of 1% of income while those earning $500,000 or more per year would pay 6% of income. The population then, as now, was largely in support of the measure. After all, who cares if the government taxes someone else to meet the needs of the country as long as it doesn't tax me?

The bulk of the taxes did not long remain confined to the top 1% after ratification of the 16th amendment on February 3, 1913. By 1918, Congress under President Wilson had increased the taxes rates for all Americans while raising the top tax rate to 77% of income. In like fashion, one can expect the marginal tax rates for the entire middle class today to increase following any increase in the top tax rate of individuals in order to satisfy the government's insatiable need for revenue.

Philosophically, I have a problem with any government requiring any citizen to pay taxes in excess of 50% of what he/she earns. If more than 50% can be taken, we run the risk of essentially allowing our government to enslave its population. There exists a real danger that, motivated by the noblest of intentions, the progressives in our government will enslave us with a completely clear conscience, convinced that they are acting in our best interest. To quote C.S. Lewis:

> *"Of all tyrannies, a tyranny sincerely exercised for the good of its victims may be the most oppressive. It would be better to live under robber barons than under omnipotent moral busybodies. The robber baron's cruelty may sometimes sleep, his cupidity may at some point be satiated; but those who torment us for our own good will torment us without end for they do so with the approval of their own conscience."*

Again, lest I be accused of fear mongering, we would do well to remember that the top tax rate remained at 77% until the tax reforms initiated under President Reagan. Government should exist to serve the population, not the other way around.

There is a well-known adage. *Give a man a fish and you feed him for a day. Teach a man to fish and you feed him for life.* Under socialism, we are doing more of the former than the latter. It is as though we have a limited, annual amount of grain with which to feed the population. Under a capitalist system, our farmers would be encouraged to retain 10% of the grain as seed to replant and expand the supply of grain to feed an expanding population. Under the socialist system, all of the grain would be distributed among the population according to need, with portions decreasing as the population expands. Eventually, the grain stores become inadequate.

Our country has been progressing down the road to socialism for 80 years since 1932. The former Soviet Union lasted 70 years from 1917 to 1987 before its grain stores became inadequate. How much longer can the U.S. survive if we continue on a similar path? We are already feeling the strain of limited resources.

I believe that we have reached a tipping point in our country to where we actually require an amendment to the U.S. Constitution to protect our citizens from excessive taxation. The sum total of all taxes, levies, assessments, etc. paid by any individual to federal, state and local governments should be barred from exceeding 50% of any individual's income. It is the only way that we can force our government to budget its resources rather than extract more resources from its population. It is the only way that we can ensure that our nation remains true to its capitalist roots and does not devolve into a socialist tyranny.

I have been living under just such a tyranny for 20 years. In 1992, the State of Minnesota opted to be the vanguard for the medical social

reform that the state's leaders were certain would occur nationally under the Clinton administration. The State of Minnesota introduced legislation to provide a state plan for the uninsured whose earnings were too large to allow them to qualify for Medicaid. The legislation was enacted in 1992 under the name Minnesota Care to provide immediate subsidized coverage for low-and-moderate-income working families but with the expressed goal of reaching universal coverage for the state by 1997 under a single payer system.

When the tide of public opinion turned against what was then termed "Hillary-Care," the state abandoned its efforts at achieving universal coverage under Minnesota Care and instead attempted to establish three competing fully integrated healthcare systems. Under the revised state plan, Minnesota would provide all privately funded healthcare through three insurers, Blue Cross/Blue Shield, Health Partners, and Medica. Those three insurers would own and operate all of the hospitals and medical clinics in Minnesota in order to provide efficiencies that would control cost within each vertically integrated system. The three vertically integrated systems would then compete with one another to contain overall cost. While this vertical integration never fully materialized, and hence private enterprise within the medical community in Minnesota still exists, the state's action did serve to eliminate almost all health insurance competition within Minnesota to the benefit of these three insurers and to the detriment of Minnesota's insured population.

Minnesota Care, as Minnesota's subsidized program for low-to-moderate-income working families, did survive the chaos of this period. Eligibility for Minnesota Care was set for families at an income level at or below 275% of federal poverty guidelines in 1993 and at 125% of federal poverty guidelines for individuals. The income limit for individuals was raised to 175% of federal poverty guidelines in

1997, 200% of federal poverty guidelines in 2007 and 250% of federal poverty guidelines in 2009 to expand eligibility.

Funding for Minnesota Care was largely provided by levying a new tax exclusively on healthcare providers. This provider tax was set at 2% of gross revenue. Funding also comes from a 1% tax on HMO premiums. At its inception in 1993, the provider tax was challenged as unconstitutional as it singled out providers of healthcare for taxation. The Minnesota Supreme Court, however, ruled that because the law governing Minnesota Care allowed for the tax to be passed through from the providers to the consumers of healthcare, the tax was not a tax levied on providers but, rather, a tax levied on all healthcare consumers and was therefore allowable. The analogy was made to taxes on tobacco which are collected by the sellers of tobacco but paid by the consumers of tobacco.

While true in theory, the reality is far different. Minnesota, more than the rest of the nation, is heavily dominated by managed care insurers. This, as noted above, is consequent to policies adopted by the same legislators that framed Minnesota Care. In their eagerness to reform healthcare, they eliminated virtually all but three private insurers—Blue Cross/Blue Shield, Medica, and Health Partners. Physicians participating with these insurance plans are required to accept as payment-in-full the fee schedules imposed by those insurance plans. These plans allege to have included the provider tax in their fee schedules but there is no evidence that this was ever done. Fee schedules in 1993, when the tax was first assessed, were, at best, only 2% higher than they were in 1992. If the plans incorporated the tax in the fee schedules, they did so by offsetting the annual rate increase by the amount of the tax. Providers of healthcare, prohibited by the insurance plan fee schedules from passing the tax on to the consumers of healthcare enrolled in those plans, were left to pay the tax out of

their earnings. Recognizing this, the Minnesota Department of Revenue has issued a policy statement that the providers of healthcare are responsible for payment of the provider tax in the event that the tax is not paid by any other party.

This is no small matter. As will be explained in the next chapter, profit margins for physicians in Minnesota have been falling progressively for the last 20 years. Where a 50% margin of profit was standard in the early 1980s, most practices are now operating on profit margins of 20% or less. Thus, to earn an annual income of $100,000, a physician with a 20% profit margin would need to generate $500,000 in revenue. The 2% provider tax would, however, cost that physician another $10,000. This reduces the physician's gross income to $90,000, representing a 10% additional tax on his/her income. Shrink that profit margin to 10%, and that same physician would need to work twice as hard and generate $1,000,000 in revenue to earn the same $100,000. But now the 2% tax on $1,000,000 is $20,000. As his/her reward for working twice as hard, the same physician's gross income is now reduced to $80,000, representing a 20% tax on his/her income. Worse yet, if declining revenues from cost-containment efforts on the part of the federal, state and private insurance payers reduce that profit margin to 5%, that same physician working long hours to generate $1,000,000 in revenue can only be paid $50,000 in income. The provider tax, however, stays the same. 2% of $1,000,000 is still $20,000. Reducing the $50,000 earned by the provider by $20,000 leaves a gross income of $30,000, representing a 40% tax on his/her income before Federal, State, Social Security and Medicare taxes are even considered. This is a shamefully regressive tax for a state that prides itself on progressive policies. The burden of this tax falls hardest on the physicians who earn the least and this problem will only worsen as government and private insurers continue to collaborate to

aggressively reduce healthcare spending and, in the process, continue to reduce the profit margins of healthcare providers.

So, what happens if a given healthcare provider actually fails to make a profit and is forced to either close his/her practice or borrow funds to maintain the practice? Surely, the same compassionate government so concerned about providing healthcare for low-moderate-income families would be understanding and forgive the tax. Don't bet on it. The Minnesota Department of Revenue will not only demand payment of the tax but will also add a 25% penalty as punishment for the inability to pay the tax. They will also begin assessing interest. Continued failure to pay will result in the State of Minnesota revoking the physician's license to practice medicine. The state will then impose an assessment of personal liability for the tax, penalties and interest. The physician's personal assets will then be seized to satisfy the debt. Surely, no greater tyranny exists than the tyranny of socialism, for the State of Minnesota would entertain no doubt in the justice of its actions.

Nor does there stand any greater example of the inefficiency and corruption, which I believe inevitably characterizes government run healthcare, than Minnesota Care. From 1993 to 2006, annual spending by Minnesota Care grew from $33 million to $438 million. Defenders of Minnesota Care will ascribe this growth in spending to growth in enrollment. This is in part true. Enrollment grew 365% from 35,217 in 1993 to 128,733 in 2006. Spending, however, grew 1,328% in this same timeframe, averaging 102% per year. Enrollment in Minnesota Care peaked at 151,205. Enrollment has declined every year since but spending has nonetheless continued to rise[22]. In 2009 there were 118,000 people enrolled in Minnesota Care but spending had grown from $438 million in 2006 to $526 million in 2009, another 20% in three years. According to the Minnesota Department of Health, private healthcare spending in the same three years rose a total of 11.2%.[23]

The Health Care Access Fund is a dedicated fund into which the provider tax is deposited and from which funds are to be drawn to pay for Minnesota Care. From the beginning, the fund has taken in more tax dollars than it has spent. That surplus has made the fund a target for progressives who are intent on spending the surplus by expanding benefits under Minnesota Care. That surplus is also a target for progressives and conservatives, alike, who raid the Health Care Access Fund to resolve budget deficits. Governor Tim Pawlenty, a Republican, transferred over $300 million from the Health Care Access Fund to the General Fund to cover budget deficits during his term[24]. Governor Mark Dayton, a Democrat, has taken a more devious approach to raiding the Health Care Access Fund. Medicare and Medicaid are funded by payroll taxes paid to the federal government. The federal government returns those funds to the states for payment of healthcare expenses under those programs. Those payments from the federal government go into the State of Minnesota's General Fund. Governor Dayton, to balance his budget, has proposed retaining those federal payments in the General Fund and "refinancing" Medicaid recipients under GAMC by paying them out of the Health Care Access Fund. According to Minnesota State Representative Doug Magnus, the proposal would essentially drain the Health Care Access Fund of $461 million in 2010-11 and bankrupt the fund by 2013[25]. But, hey, we could then just increase the provider tax.

According to the Minnesota Department of Revenue, the Health Care Access Fund received $934 million in provider taxes and $138 million in HMO premium taxes in fiscal year 2010-11 for a total of $1.072 billion[26]. So, with all this money from healthcare providers, the State of Minnesota is surely paying providers well for the care they provide to low-moderate-income individuals and families, right? Wrong! Payment to providers is set at the Medicaid fee schedule. For

the same one hour new patient evaluation noted above that Medicare pays $152.16, Minnesota Care pays a generous $135.81. For the same follow up visit that Medicare pays $67.02, Minnesota Care pays $53.34. Even injectible drugs are underpaid. Botox injections are now the standard of care for chronic migraine. The 200 units of Botox required for these injections costs me $1,050. MN Care reimburses me $969, so that I am actually subsidizing the cost of the Botox treatment for the State of Minnesota. I've already illustrated that Medicare's fee schedule would not allow a practice to exist without offsetting Medicare's payments with larger payments from other sources. This is even truer for Minnesota Care. Nevertheless, if I were somehow able to reduce expenses sufficiently to eke out a 5% profit margin, Minnesota Care's fee schedule for a one hour new patient evaluation would translate into a wage paid to me of $6.79 per hour. While Minnesota's socialists prattle on about the right to healthcare for all Minnesotans, it is quite clear that Minnesota Cares little for its physicians.

After almost a decade of government run healthcare in Minnesota, there is sufficient evidence of a combination of crass inefficiency and blatant indifference to the needs of healthcare providers to conclusively state that socialized medicine does not work. The diversion of funds from Minnesota's Health Care Access Fund to solve budget deficits rather than addressing spending in order to balance a budget would, I believe, only be played out on a larger scale should we be foolish enough to allow socialization of all medical care on a national scale. With funds drained from healthcare reserves to cover budget shortfalls elsewhere, payment to physicians would be reduced to the point where doctors are forced to ration care to an extent inconsistent with their core beliefs. Such rationing would eliminate the spiritual rewards associated with the practice of medicine to the same extent that the fee schedules and other cost-containment measures have

eliminated the financial rewards. Fewer and fewer competent people will enter or continue the practice of medicine in a system that fails to reward them, resulting in a progressive decline in the quality of care available. It may, therefore, ironically be deemed a blessing when ultimately even that care is severely rationed.

Chapter Four

The Problem with Managed Care

When I concluded my formal training and entered private prac-
tice in 1983, managed care did not exist. The practice of medicine
was still a free market enterprise. Physicians entering practice set
their fees based on existing competition. Insurers paid physicians
based on usual, customary, and reasonable (UCR) charges. The usual
charge was the charge billed by the physician for the service in the
preceding year. The customary charge was based on the prevailing
range of charges in a geographic area. The reasonableness of a charge
was determined by the complexity of a service which warranted an
increase in payment over the usual and customary charge. Insurers
paid physicians the lower of the usual or customary charge. Thus, if a
physician's usual charge was particularly low for a given geographic
area, that physician would be paid in accordance with his/her usual
charge instead of the customary charge for the geographic area. If the
usual charge was higher than the customary charge, the customary
would be paid instead of the usual charge. This method of insurance
payment for physician services incentivized physicians to update their
usual charges annually to prevent those charges from lagging behind
the customary charge for the area and no doubt contributed to the
medical inflation of the 1970s and 1980s.

The first incursion of managed care into traditional medical practice
occurred in the early 1980s in the form of Health Maintenance Organi-
zations (HMOs). The staff model HMO represents the HMO concept
in its purest form. Under the staff model HMO, physicians in group
practice eliminated the insurer. The HMO negotiated contracts with

businesses and individuals directly to offer comprehensive health coverage at a fixed price per person (capitated rate) but required all care to be provided by the physicians in the HMO. By eliminating the administrative costs and profits associated with the insurer, the HMO was able to offer healthcare services at a lower rate than traditional health insurance companies and this created a competitive advantage for them.

Success, however, often breeds its own set of problems. As the HMO market grew, so did competition for market share. The traditional health insurers did not sit idly by and watch their market erode. To compete with the price points of HMOs, the traditional insurers formed Preferred Provider Organizations (PPOs). The PPOs established networks of physicians who were required to offer their services at a discount in return for membership in the network. These provider discounts allowed the insurers to compete with the price points of the HMOs.

Increasing competition from PPOs led to an expanded role of administrators within the HMOs to address the threat from PPOs. As administrators within the HMO industry acquired increasing levels of control over the HMOs, the physicians within the HMOs became relegated to the role of employees and the HMOs ultimately transformed themselves into a variation of the very insurer that they were initially conceived to eliminate. As administrative costs rose within the HMOs, the initial promise of cost containment was lost. Simultaneously, the quality of care deteriorated as administrator-run HMOs focused their attention on rationing care to contain cost and remain competitive. By 1995, public dissatisfaction with HMOs had reached a peak. What had started as a well intended effort to transform the healthcare landscape to provide quality healthcare at an affordable price by eliminating insurer profits had failed. Paradoxically, consumer choice and physician autonomy had diminished while the position of the administrator/insurer strengthened.

More importantly, however, the establishment of PPOs and provider networks created a subtle but powerful shift in the relationships between doctors, healthcare consumers and insurers; a shift that was not immediately apparent to the medical community involved in the transformation. Prior to the development of PPOs, healthcare consumers chose their doctors and hospitals and a commercial contractual relationship existed exclusively between them. The doctor-patient relationship was primary and inviolate. The insurer was simply a third party payer with no voice in which doctor or hospital was chosen by the insured and certainly no say in the care that was provided.

PPOs changed the very nature of those relationships. The primary contractual arrangement was now between the health insurer and the insured. It was the insurer who now granted the doctor or hospital access to their population. It was the physicians and hospitals that were relegated to a third party status. The eponym Provider in Preferred Provider Organizations spoke volumes. The doctor-patient relationship was dead. As if to emphasize this, all participants in the practice of medicine were now designated as providers and, by implication, all providers are interchangeable. The stage was now set for the emergence of managed care systems.

By the early 1990s, after a decade of PPO expansion, it was a rare physician who still practiced outside of an insurance company's provider network. Most physician groups and most individual physicians belonged to multiple provider networks operated by various diverse health insurers. Payments to physicians were still made in accordance with UCR guidelines but this was about to change. Harvard University had conducted a study on physician reimbursement from 1985 to 1989 and published the results of their study in 1989. The Harvard group recommended that physician payment be altered to compensate physicians more for cognitive tasks and less for procedural tasks. The

result was the Resource Based Relative Value Scale (RBRVS) formula to set physician payment. The formula considered training, experience, effort, practice expense and malpractice costs in setting the fees associated with each procedural code. Medicare adopted the Relative Value Scale in the Medicare Reform Act of 1989 signed into law by President George Bush and imposed fee schedules for Medicare in place of UCR payments for all physician services effective 1992.

Private insurers quickly adopted Medicare's approach and established fee schedules of their own to contain payment for medical services. United Health Care even developed a specific branch, Ingenix, to gather data by which to set fee schedules and then sell that data to other insurers. Thus, by 1993, physicians had been relegated to the unenviable status of something between employees and vendors in the healthcare system. Just like employees, physician payment rates were set by their "employers," the state and federal governments and the private insurers. Unlike employees, however, there were no employer sponsored 401k or pension plans. No employer paid half of their Medicare and Social Security taxes. There were no paid vacations or paid holidays. None of the physician's practice expenses were reimbursable. Like other vendors in healthcare, physicians were responsible for all of the expenses in running their practices. They were responsible for ensuring that their services were competitive and desired in the marketplace. Unlike other vendors, however, physicians could no longer adjust their charges to ensure appropriate margins of profit.

The imposition of fee schedules did have the desired effect of reducing healthcare expenses for the federal and state governments and the private insurers. From 1993 to 2001, overall physician payment from these sources declined 39%. Difficult as it is for anyone to accept such a steep drop in income, I believe that most physicians would have been content with the decrease if, in fact, the reduction in healthcare

delivery cost had actually rendered healthcare more affordable. It did not. From 1993 to 2001, insurance premiums rose an average of 56%. From 2001 to 2008, average health insurance premiums rose another 78% or 11% per year. Worker wages from 2001 to 2008 rose 18% or 2.5% per year while physician fee schedules from 2001 to 2008 rose an average of 7% or 1% per year.

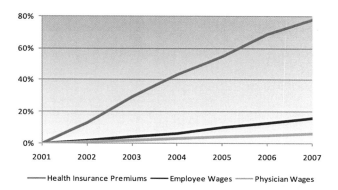

The disparity between the rise in health insurance premiums and physician payments has simply created wider profit margins for the insurers and, in turn, more generous compensation packages for health insurance executives. William McGuire, M.D, the former CEO of United Health Care, received an average annual salary of $52 million and a total of $1.7 billion in stock during his tenure as CEO. United Health Care's current CEO, Stephen Hemsley, was paid $48.8 million in 2011[1]. George Paz, the CEO of Express Scripts (a pharmacy benefit management corp.) was paid $51.5 million in 2011[1]. Thomas Ryan, CEO of CVS Caremark (pharmacy chain and pharmacy benefits manager) was paid $68 million in 2011[1]. Joel Gemunder of Omnicare (the nation's largest dispenser of pharmaceutical's to nursing homes) was paid $98.3 million[1]. Of the seven highest paid CEOs in 2011, five are from healthcare[1]; this at a time when healthcare is becoming increas-

ingly unaffordable for the majority of employers and individuals and healthcare rationing is becoming more commonplace.

The problem is not simply that these CEOs and the rest of the management hierarchy are overpaid but that their income is derived largely by impeding the access to quality healthcare for consumers by a combination of direct healthcare rationing and reduced payments to providers of healthcare. These CEOs will argue that their income is consequent to improvements in share prices and not from reductions in care. This argument is disingenuous. Share prices do not rise unless corporate profits rise or are, at least, expected to rise. The major factors driving corporate profits for these companies is healthcare rationing and reduced healthcare provider payments.Therefore, the excesses in payment to managed care executives do occur largely at the expense of the individuals they insure and the professionals who provide care for their insured. This represents an enormous economic drain on the healthcare system and it is disgraceful that the very managed care executives who are instrumental in devising the various mechanisms for rationing healthcare are being so richly rewarded for denying the very care that they are being paid to provide.

So why have we allowed this to come about? The answer lies in how the healthcare debate has been framed over the last thirty years and that framing starts with the very definition of the cost of healthcare. On the surface, that definition may seem simple. Deeper analysis, however, reveals that the definition depends upon the per-spective of the entity discussing healthcare costs. Via Medicare, the federal government has become the single largest insurer of healthcare in the United States. The federal government and the private insurers therefore view healthcare costs from the same perspective. For them, healthcare costs are equivalent to the cost of providing healthcare. Because the healthcare debate has been largely a political debate, con-

taining the cost of healthcare has been exclusively discussed in terms of reducing healthcare delivery costs.

For employers purchasing health insurance for their employees, however, the cost of healthcare is almost exclusively the cost of the premium paid to the insurer to provide healthcare coverage. Thus for employers and their employees, the cost of healthcare is defined as the cost of the health insurance premiums. The cost of healthcare delivery is important only to the extent that it increases the insurance premium.

As noted above, the healthcare debate in the United States has taken place almost exclusively from the perspective of the insurer. Therefore, the emphasis has been to manage care in an effort to exclusively contain healthcare delivery costs. Containing the rising cost of health insurance premiums has never been a primary concern. It was simply assumed that if healthcare delivery costs declined so would insurance premiums. Thirty years of managed care with declining healthcare reimbursement and continuously escalating health insurance premiums has proved that assumption to be invalid. This should come as no surprise. The managed care model has placed the health insurer in charge of containing cost. Cost to the insurer is not the health insurance premium. That premium is revenue, not cost, for the insurer. What company would voluntarily act to restrain its growth in revenue?

The disconnect between health insurance premiums and the cost of healthcare delivery has never been more apparent than in 2011. According to the Kaiser Family Foundation, the cost of employer-sponsored health insurance family coverage rose 9% to $15,073 per year while the cost of individual coverage rose 8% to $5,429 per year. These were the largest increases in five years, bringing the total rise in health insurance premiums to a staggering 113% since 2001, and occurred even as healthcare utilization decreased in 2011 from 2010 levels[2].

Karen Ignagni, president of America's Health Insurance Plans, predictably attributed the rise in premiums to a rise in healthcare costs, citing a report by Standard and Poor's that found a nearly 8% increase in healthcare costs in the year ending July 2011[2]. The question, however, is whether the costs reported are based upon the charges submitted for services or the amount actually paid for those services. While an insurer can point to an 8% increase in charges submitted by healthcare providers, that increase is meaningless in a predominantly managed care environment where payment is fixed by fee schedules whose annual increases are largely dictated by the insurers and do not match the increase in provider charges. So if utilization of services declined and healthcare provider payments did not increase more than 1%, how can a 9% increase in premium represent anything other than profit for the insurer?

That it can't is reflected in a report by Barclays Capital that showed that "13 of the nation's top 14 health insurers beat their projected earnings for the first quarter, with profits averaging more than 46 percent higher than expected."[2] Wellcare Health Plans, providing managed healthcare services through government programs such as Medicaid and Medicare to 2.2 million recipients, saw earnings in 2011 grow 730%[3]. Health Net, providing managed care services through HMO and PPO plans to 6.0 million members saw earnings in 2001 grow 266%[3]. Aetna, providing managed care services through HMO and PPO plans to 18.5 million members saw earnings in 2011 grow 169%[3]. Molina Healthcare, providing managed care services to 1.6 million members via government-sponsored programs for low income families saw earnings in 2011 grow 117%[3]. Humana, providing managed care services through HMO, PPO, and government contracts to 10.2 million members, saw earnings in 2011 grow 72%[3]. CIGNA, providing managed care services through HMO and PPO plans to

12.47 million members, saw earnings in 2011 grow 53%[3]. United-health Group, providing managed care services through HMO, PPO and government contracts to over 75 million members, saw earnings in 2011 grow 62%[3].

Were not the cost of healthcare exclusively defined as the cost of healthcare delivery, these numbers would represent an alarming increase in earnings for companies explicitly tasked with keeping the cost of healthcare down. To the extent that these increases in earnings are consequent to increases in health insurance premiums and/or government subsidies, they should raise concern. The sad truth, however, is that these companies do equate the cost of healthcare with the cost of healthcare delivery and these earnings, therefore, serve only as benchmarks of their success. To the extent that these earnings eventually translate into executive salaries, bonuses, corporate profit and investor profit, these are funds siphoned out of the healthcare community and into the business and investor communities. Once lost, these funds can never be regained. Their loss will serve to simply fuel the next round of healthcare premium increases, healthcare rationing and reduction in provider payments to drive the next round of profits.

To illustrate how effectively the managed care environment has reduced healthcare delivery costs, particularly physician payments, I will again cite specific examples from my practice and the fee schedules from two insurers—Medica (Unitedhealth Group) and Blue Cross/Blue Shield of Minnesota. Let us assume that I work 5 days per week and see patients from 9 a.m. to 5 p.m. with 1 hour off for lunch. This provides 7 hours per day in which to provide patient care in a total of 261 days per year. My office is closed for holidays 10 days per year. I am required to take continuing medical education course to maintain my license and this will leave me absent 5 more days per year. If I take 2 weeks of vacation per year, this will leave me

absent another 10 days per year. The total number of days available to provide patient care is thus 236 days per year. New patient consults are scheduled as 1 hour visits and follow up appointments are scheduled as 15 minute visits. Let us further assume that I see 4 new patients per day, leaving 3 hours per day for follow-up visits. At 4 per hour, this would allow 12 follow-up visits per day.

Medica's fee schedule allows me a maximum payment of $339.12 per new patient consult. At 4 per day for 236 days this would produce revenue of $320,129.28 per year. The fee schedule for follow-up visits depends on the complexity of the visit. Let us assume the level of complexity is equally divided between the follow-up visits so that 50% are paid at $138.24 per visit and 50% are paid at $91.80 per visit producing an average of $115.02 per visit. At 12 per day for 236 days, this would produce revenue of $325,736.64. Assuming every appointment was filled and kept, this would produce total annual revenue of $645,865.92.

Keeping the same three employees as in chapter two—one receptionist, one billing person and one transcriptionist—expenses are about $450,000 as outlined in that chapter. This leaves a potential profit of approximately $195,000—not a bad annual income. Of course, this would be decreased by $13,000 due to Minnesota's provider tax of 2% of gross revenue, reducing that potential profit to $182,000—still not a bad annual income. However, this requires that every available appointment is actually filled. Perfection never happens in the real world. Assuming a realistic fill rate of 80%, the annual revenue for the year drops to $516,692.73 reducing profit to only $66,692.73. This is reduced by $10,333 to cover Minnesota's provider tax, leaving $56,359.73 for the year. If the fill rate drops another 5% so that 25% of the available appointments are unfilled, annual revenue is only $484,399.44 and profit drops to $34,399.44. This is reduced by $9,688

to cover Minnesota's provider tax, leaving $24,711.44 in income for the year. Simply to break even, fill rates must be at least 70%.

While significantly better than anything the federal and state governments offer, these profit margins are still too thin and are unhealthy for a service industry. Overhead should not consume more than 50% of maximum revenue. That it does is the result of increases in operating costs which have risen faster than fee schedule increases. It is the direct result of the insurers chipping away at fee schedules in order to reduce the cost of healthcare delivery and doing so entirely at the expense of the professionals who are providing that healthcare. It is the direct result of a healthcare system which does not allow physicians the autonomy to adjust their fees to accommodate for increases in expenses.

So, you say, if the fee schedules are so bad, why not refuse to participate in the insurer's network and not be bound by the fee schedule? To answer that question, let us examine the payment structure from Blue Cross/Blue Shield of Minnesota for out-of-network physicians. For the same consult that Medica allowed $339.12 in network, Blue Cross allows only $226.52 for an out-of-network physician. And this is not even the amount that they will pay but the maximum amount that they will allow for the consult. Because I am out of network, they will actually pay 80% of that amount or $181.21. Therefore, if I charge $535 for a 1 hour new patient consult as I indicated in chapter 2, the patient will be responsible for $353.79 or 66% of the bill. For the same follow-up visit that Medica pays $138.24, Blue Cross will allow $92.34 and pay $73.87. My current charge for this level of follow-up is $300. The patients insured by Blue Cross would consequently be left responsible for 74% of their bill for each visit. For the same follow-up visit that Medica pays $91.80, Blue Cross will allow $61.32 and pay $49.05. My current charge for this level of follow-

up is $175. The patients insured by Blue Cross would consequently be left responsible for 72% of their bill for each of these visits. In addition, these payments are only made after the patient has satisfied an entirely separate deductible from that for in-network physicians. Furthermore, because I am out-of-network and the patients know that their insurance will pay less, it will be much harder to attract patients, increasing my advertising expense.

Blue Cross and every other insurer have simply structured their contracts to make the use of out-of-network physicians cost prohibitive for their subscribers. In this manner, the health insurers control the physicians by locking them out of their markets if those physicians are unwilling to live with the fee schedules that the insurers impose. The insurers simultaneously control the health care consumer by forcing that consumer to function as though he/she had no insurance, in spite of the significant premiums paid, if he/she elects to pursue treatment outside of the insurer's network. Were these restrictions on physician autonomy and consumer choice resulting in affordable healthcare, they might be palatable. Unfortunately, however, neither the healthcare provider nor the healthcare consumer have derived any benefit from this arrangement. The healthcare insurers have simply collaborated to offer the same range of limited choice to providers and consumers alike and, in the process, maximize their profits. In the largest study of its kind, a 2008 American Medical Association report described a "steep decline in competition in the nation's health insurance markets...Patients do not appear to be benefiting from the consolidation in health insurance markets...Health insurers are posting historically high profit margins, yet patient health insurance premiums continue to rise without an expansion of benefits."

There are limits on premium increases which can be imposed by the Commerce Department in each state and, in fact, premium

increases have to be approved by the Secretary of Commerce. What is not known to the average consumer, however, is that the health insurers are allowed to place up to 25% of their annual revenue into reserves. These reserves are treated as an expense and profit is consequently calculated after the reserves are deducted from revenue. It is therefore easy for health insurers to post losses in any given year and apply for, and be granted, premium increases. For example, if an insurer has a 20% profit at the end of a year and places 25% of its revenue into reserves, that 20% profit now becomes a 5% loss and justifies a premium increase. With the exception of 2011, where the profits were simply so high as to engulf the 25% deposited into reserves and still show additional profit, this has gone on year after year resulting in escalating insurance premiums and swollen insurance company reserves. As investment income from these reserves is also shielded from taxation, these have become truly massive and are used to fund acquisitions of healthcare provider networks and/or competitors within the insurance community.

As bad as the current environment is, however, it is my opinion that we have not yet seen the worst if this process is allowed to continue unfettered. Part what makes my practice attractive to my patients is that I have the freedom to spend as much time with them as they require. I know each and every patient that walks through the door and it is that familiarity that represents an important part of the doctor-patient relationship. Another part of that relationship is that they can rely on me as their advocate in any reasonable conflict that they may have with their insurer over the care that they require. By contrast, many of my patients complain about the impersonal nature of large group practices. It is becoming less and less common for a patient within these practices to be consistently treated by a single physician whom they have come to know and trust. The patients frequently feel

rushed, with one of my patients summing up the encounter with his physician in a single, pithy phrase. "I felt as if he was shaking my hand good-bye as I entered the exam room."

Practices such as mine, however, are becoming extinct. According to the Englewood-based Medical Group Management Association (MGMA), 1-2 physician practices nationally have decreased by over 50% in the last 25 years as a result of the economic dynamics outlined above. BDC Advisors, a national consulting firm for hospitals, noted in their report "Trends in Physician-Hospital Integration" that "average physician income adjusted for inflation fell 7 percent between 1995 and 2003"[4]. When these dynamics alone are not sufficient, the insurers are not above the use of more drastic measures to force individual physicians out of solo or small group practice. Again, I have personal experience here. I had succeeded in bucking the economic trend in medicine with gross revenues for my practice nearly tripling between 1996 and 2006. About 50% of that revenue was derived from Blue Cross Blue Shield of Minnesota. That I was succeeding in an environment where others were failing prompted scrutiny from Blue Cross who initiated an audit of my practice in November of 2006. In January of 2007, the audit ended, as I assured them it would, with no evidence of fraud. This, however, did not satisfy Blue Cross as I was still guilty of building a successful solo practice. In March of 2007, I received notification from Blue Cross Blue Shield of Minnesota that they were exercising the provision in the provider contract to terminate my contract without cause and that I would consequently no longer function as a network provider for Blue Cross after June 30, 2007.

This simple move on the part of Blue Cross Blue Shield of Minnesota served to reduce the volume and revenue of my practice by 50% and, in effect, reduced the value of my practice to nearly zero as the remaining 50% barely covered overhead. To add insult to injury, from

March of 2007 to July of 2007, while I was still a contracted network provider for Blue Cross, no payments for Blue Cross subscribers were made to my practice. We were simply notified that payment was being delayed pending revue of the claims.

Once the contract terminated in July of 2007, Blue Cross then notified me that all of the services provided to Blue Cross members from March of 2007 to June 30, 2007 were being denied as not medically necessary. Furthermore, the contract, by which I was bound through June 30, 2007, prohibited my office from billing those members directly for the unpaid services. Finally, Blue Cross also advised my office that they had reviewed the payments made from January 1, 2007 through March of 2007 and were retracting those payments as not medically necessary. In essence, my office had provided 6 months worth of services to Blue Cross subscribers which were either never going to be paid or whose payments were being retracted. This amounted to over $278,000 in lost revenue.

In August of 2008, I consulted an attorney, Mike Hatch. Mr. Hatch was a former Attorney General for the State of Minnesota as well as a candidate for governor from the Democratic Party. I purposefully chose Mr. Hatch because of his former role as Attorney General. Before taking Blue Cross into arbitration over their non-payment, I wanted someone who had knowledge and experience with provider fraud to look over my billings and make sure that I had not done anything remotely wrong. After a careful examination, Mr. Hatch elected to represent me and filed for arbitration.

Like most physicians, I had no prior experience with the arbitration process. I quickly learned, however, that the process is constructed to favor the insurer which, I assume, is why all provider contracts with insurers mandate arbitration as the only recourse to settle any disputes. In this process, the only claim a physician is allowed is for the amount

that can be documented as unpaid per the existing fee schedule. Even though the insurer breeched the contract by failing to make payment as provided under the terms of the contract, the contractual discount cannot be voided and the insurer held liable for payment of the amount charged by the physician, which typically exceeds the amount allowed under the contract's fee schedule. Furthermore, no claims for punitive damages are allowed. The only liability the insurer has in this process is for the amount that they would have been required to pay had they not refused to make payment in the first place. The insurer's only exposure is the cost of the arbitration. In other words, the insurer has little to lose and everything to gain by withholding payment and forcing arbitration.

The process of choosing the arbitrator is also designed to favor the insurer. Each side submits a list of names that they propose to serve as an arbitrator. If neither side agrees on the choice of an arbitrator, each side picks one name from their list and those two individuals then select the arbitrator to be used. In my arbitration, Mr. Hatch advised against allowing the latter process as it entailed too much risk. Blue Cross rejected every name on Mr. Hatch's list and Mr. Hatch consequently accepted the choice of Judge Robert Lynn from Blue Cross' list.

Mr. Hatch was familiar with Judge Lynn and felt he was our best choice. Mr. Hatch described Judge Lynn as a fair judge but he also warned me that arbitration differs from the trial process. In the trial process, one side typically wins and one side typically loses. In the arbitration process, the judge typically views the claim as a loaf of bread to be divided between the parties. Therefore, in the best case scenario, I was likely to emerge with less than I was owed.

The arbitration process also allows maneuvers that a trial process would not. At the commencement of the arbitration and throughout the course of the arbitration, Blue Cross presented a list of counter-claims

that would have been disallowed in a trial process as not previously disclosed. Those counter-claims included Blue Cross' assertion that they could recoup payments made for services provided in prior years. This came as a shock not only to me but to my attorney as well. The written provider agreement with Blue Cross allowed for a 15 month window in which a provider could submit a previously omitted claim or correct a previous claim which was under-billed. Likewise, the insurer had the same 15 month window in which to amend a payment previously made. The only exception to the limitation was in the instance of fraud.

The attorney for Blue Cross quoted the definitions section in the written contract in which Blue Cross defines the entire contract as "this Agreement and any attachments and amendments thereto including but not limited to any Rules and Regulations, Provider Bulletins and provisions of the Provider Policy and Procedure Manual in effect (available on Blue Cross' web site at bluecrossmn.com), applicable fee schedule, and any other attachments which constitute the entire Agreement between the parties." The attorney for Blue Cross then provided a copy of a Provider Bulletin from 2003 in which Blue Cross had eliminated its own 15 month restriction for amendment of payments but retained the 15 month restriction for provider amendment of claims. He further alleged that this was also stated in the online Policy and Procedure Manual, though neither I nor my attorney could find it in the 500 pages of online material.

With the 15 month window eliminated, Blue Cross now asserted its counter-claims. They claimed that the therapists employed in my practice required direct supervision and therefore I could not legitimately bill for services performed when I was not present in the same office in which the therapy was performed. They claimed that they had been over-billed for the units of therapy performed. They claimed

that the medical records were inadequate to support the billing and that all of the billing should therefore be denied. They claimed that these amendments to payment should extend back eight years to 2000. Blue Cross stated that the actual amount owed to them would be calculated after the arbitration but that, at a minimum, that amount stood at $184,822.29.

Thus from day one of the arbitration, Blue Cross transformed the arbitration from one in which they were the defendant to one in which they were the plaintiff and in which I had become the defendant. The process of defending myself against these counter-claims occupied almost the entire arbitration, which lasted for more than six 8 hour days. This effectively diverted attention from my original strategy for proving the medical necessity of treatment. The planned testimony of my patients whose treatment was being contested was abandoned due to lack of time as Blue Cross controlled the schedule and pace of testimony throughout the arbitration.

Ultimately, Judge Lynn ruled favorably for me. All of the counter-claims brought by Blue Cross were dismissed. Of the 57 patients whose treatment Blue Cross denied as not medically necessary, Judge Lynn ruled that only six had received treatment which could be deemed not medically necessary. He did, however, allow Blue Cross to recoup payment for services on these six as far back as January 1, 2006 and in that ruling accomplished for Blue Cross what Mr. Hatch had warned me of. The loaf was split so that, after attorney fees, which Mr. Hatch generously reduced, very little was actually paid to me by Blue Cross for the services provided to their members in 2007.

From this arbitration, I learned several things. First, in spite of the talent, time, and funds expended by me in developing my practice, I do not actually own my practice. At best, in our current managed-care environment, I lease my practice which is effectively owned by

the insurer. Second, any insurer can effectively destroy any practice it chooses by simply terminating the provider status of the practice and then reclaiming prior payments, as far into the past as desired, by contesting the medical necessity of treatment. Third, the insurers resent any challenge to their authority and will move to destroy any physician bold enough to challenge that authority. These lessons should also not be lost on the consumers of healthcare in general for they are an indication of what the future holds for healthcare consumers if the present trend continues.

1-2 doctor medical practices actually represent the most efficient and least costly system for providing healthcare that exists in our current market. Larger groups have often invested in the acquisition of laboratories, imaging centers, and out-patient surgery centers. They have more of an incentive to order questionably necessary tests or perform questionably necessary procedures. The largest groups, by virtue of their size, even have more negotiating power with the insurers and consequently have obtained more generous fee schedules than their smaller counterparts. So, if large group practices cost the insurers more, why are the insurers pressuring doctors to leave their individual practices and join these groups?

The answer, I believe, is that the insurers are content with a short term increase in cost to attain a long-term goal. That goal is to eventually own the entire healthcare delivery system. The financial problems faced by 1-2 person medical practices are also being felt by larger group practices. As a result, group practices, faced with the same financial problems, are being acquired by, or are merging with, hospitals which, in turn, are being acquired by managed care organizations to create vertically integrated healthcare systems. Within these systems, the quality of care is primarily measured by how few resources are expended on that care. I believe we are rapidly approaching the insur-

ers' desired goal of owning the entire healthcare system and, once that goal is achieved, there will be no way to rectify the damage. Who, in such a system, can advocate on behalf of a patient whose treatment is being denied. Any physician foolish enough to do so would either be penalized financially or fired outright. The insurer, protected by ERISA from malpractice claims, would be free to direct care based entirely on the desired profit margin with little or no concern for patient welfare. Rationing would become commonplace as the private insurers and the state and federal governments collaborate to contain cost and maximize revenue under the new healthcare cartel.

Part of that collaboration is the transition from the ICD-9 to the ICD-10 coding system for diagnostic categories which is currently underway. The ICD-10 coding system expands diagnostic codes from the current 18,000 to over 140,000, with codes defining everything from where an injury took place to specific injuries such as walking into a lamppost or hurting yourself while crocheting. There are 9 separate codes for Macaw related mishaps. Why do we need this degree of precision? I believe that the insurers are convinced that, if given enough data, they can construct algorithms by which to direct all medical care. This certainly fits well with the scenario outlined above in which all healthcare providers are owned by a small group of insurers whose algorithms for care can then be mandated to the healthcare providers that they employ. This system would clearly work to reduce the overall cost of healthcare delivery. After all, a given specific set of circumstances and a given specific set of symptoms should result in a given specific diagnosis, right? A given specific diagnosis should have a given specific treatment, right? And, if that's the case, even a nurse's aid can be taught to follow a simple algorithm. We can then eliminate all of those expensive visits to doctors, especially specialists, right? Actually, no, none of those are right.

John C. Goodman, president and CEO of the National Center for Policy Analysis, in an article entitled "Why Medicare's Pilot Programs Failed"[5] addresses this misconception.

"Over the past two decades, Medicare's administrators have conducted two types of demonstration projects. Disease management and care coordination demonstrations consisted of 34 programs that used nurses as care managers to educate patients about their chronic illnesses, encouraged them to follow self-care regimens, monitored their health, and tracked whether they received recommended tests and treatments. The primary goal was to save money by reducing hospitalization. With respect to these efforts, the CBO finds:

 • *On average, the 34 programs had little or no effect on hospital admissions.*
 • *In nearly every program, spending was either unchanged or increased relative to the spending that would have occurred without the program.*

Value-based payment demonstrations consisted of four programs in which Medicare made bundled payments to hospitals and physicians to cover all services connected with heart bypass surgeries. The CBO finds 'only one of the four ...yielded significant savings for the Medicare program' and in that one Medicare spending only 'declined by about 10%.'

We cannot find a single institution providing high quality, low-cost care that was created by any demand-side buyer of

care. Not the Centers for Medicare and Medicaid Services (CMS), which runs Medicare and Medicaid. Not Medicare. Not Blue Cross. Not any employer. Not any payer, anytime, anywhere.

Also, wherever we do find excellence we almost always discover it cannot be copied. Pilot programs—even when they work—are not always scalable."

Medicine is both an art and a science. The scientific data lends itself to the use of algorithms but the art of medicine lies in the application of that data to individuals. A diagnosis is only as valid as the experience and talent of the person conducting the examination render it, and the examination process cannot be done without personal interaction. Individual nuances, furthermore, require that treatment be tailored to each individual. That process, while more costly than a one-size-fits-all approach, is what constitutes quality medical care. That is the art of medicine and that art is unique to each individual medical practitioner. It cannot be copied. It is not scalable.

With dominion over all healthcare providers considered a virtual fait accompli, the managed care organizations are now turning attention to control of healthcare consumers. This began several years ago with a media campaign blaming the poor lifestyle choices of consumers for the rising cost of healthcare. The ingenuity of this approach is that it is hard to argue with. Obesity is the single greatest predictor of illness and rates of obesity in America have been steadily increasing for over 25 years. Childhood obesity has increased 700% in the last 10 years alone. Obesity significantly increases the risks of heart disease, stroke, diabetes, cancer and Alzheimer's Disease, all chronic diseases contributing to costly care and disability.

The question, however, is how serious really are the insurers in reducing obesity? The risks noted above are recognized by their actuaries and are factored into the premiums charged. To the extent that obesity rates increase the premiums that the insurers collect, does there actually exist a motivation to ignore the problem? If the cost of delivering healthcare to this population can be diminished, while the obesity rates increase premiums, ignoring the problem would serve to increase profit margins. This may sound cynical but consider the following. Body weight is basically simple—it is a function of calories consumed versus calories burned. There are consequently at least two mechanisms for controlling obesity. The dietary approach (calories consumed) is probably the least effective. Eating habits are hard to change and simply advising people to substitute vegetables for cookies, ice cream, candy and chips is not likely to effect any meaningful change. Yet billboards to this effect from various managed care organizations, as well as TV and radio ads, abound.

Motivating people to exercise (calories burned) has had a better track record, so it is not surprising that some insurers have focused more attention on this avenue. Exercise to burn more calories than are consumed and then to actually burn fat to reduce weight does, however, involve a basic understanding of the rules regarding fat burning. First, the heart rate must be above 90 beats per minute for 10 minutes before a body will enter a fat burning mode. Second, building muscle with weight-bearing exercise in addition to cardiovascular exercise will be more effective than cardiovascular exercise alone as it increases the resting metabolic rate. As these two rules are widely known, why would Blue Cross/Blue Shield of Minnesota spend millions of dollars on a campaign including television, radio and billboards to encourage people to perform routine activities such as gardening and walking your dog and specifically target the timeframe of 10 minutes 3 times

per day? Why spend millions to encourage a population to just reach the point of fat burning in an exercise activity and then stop? Could there be another motive behind these ads, one that has nothing to do with actually achieving any weight loss?

Blaming consumers of healthcare for rising healthcare costs because of lifestyle choices which managed care, despite its best efforts, has been unable to change opens the door to altering employer-sponsored healthcare. This appears to be the most current initiative for managed care. Employers are being advised that their group policies are expensive because the insurer has no ability to exclude high-risk employees from the group policy. Without the ability to exclude high-risk employees, the insurer cannot properly manage risk and this inability to manage risk is producing higher premiums for the entire group. Employers are being enticed to consider replacing these costly group policies, which are in essence defined benefit plans, with less costly individual policies, which are in effect defined contribution plans. The employer contributes a specified sum on behalf of the employee who then uses that sum to purchase his/her own individual indemnity policy tailored to his/her particular needs.

This approach is particularly attractive to young, healthy employees who can purchase policies with a minimum of benefits and bank the difference between the cost of that policy and the amount paid by their employer. *Reason Magazine* has recently reported a poll in which 48% of Americans would prefer to receive income from their employer to purchase their own health insurance rather than have that employer purchase insurance for them. When asked to rate how much trust they have in various entities to address their healthcare needs, 61% replied that they have more trust in themselves, 15% placed more trust in their employer and only 5% placed more trust in government. Likewise, employers, faced with mounting regulatory requirements from gov-

ernment and unpredictable increases in premiums, are increasingly interested in escaping their role in providing healthcare benefits.

But where will this shift from a defined benefit to a defined contribution/indemnity plan lead. Without question, these plans mitigate risk for the insurer and shift a corresponding share of that risk to the individual. These are so profitable for the insurer and carry so little risk that these policies could become all that the insurers may be willing to offer once the individual mandate under the Affordable Care Act requires individuals to purchase health insurance and produces a captive market.

To illustrate how little value these plans offer, let us take a look at a current rate and benefit sheet from Assurant Health in the defined contribution/indemnity plan Assurant® Health Access™. This plan offers 3 levels—Value, Fundamentals, and Enhanced.

The Value plan will cost a family with a primary, spouse and 2 or more children $286/month for ages 31-40, $326/month for ages 41-50 and $426/month for ages 51-63.

- This plan will pay $50 per office visit with a limit of 2 visits per calendar year.
- It will provide negotiated discounts on prescription drugs but no payment toward the cost of those drugs
- It will pay $10 per immunization and $10 per allergy shot with a limit of $100 per year for all allergy shots and immunizations.
- It will pay $150 per emergency room visit with a limit of 1 visit per calendar year.
- It will pay $200 per anesthesia event with a limit of 1 event per calendar year.
- It will pay $15 per laboratory test, $300 per CT scan, $450 per MRI scan, $50 per x-ray or ultrasound, $25 per physical therapy, occupational therapy or speech therapy visit for a total of $1,000 per calendar year

- For hospitalizations, it will pay $1,000 per day for illness and $2,000 per day for injury with a maximum of $200,000 per calendar year.

Pity the poor young family that has chosen this plan and gives birth to a premature child. Their medical costs will bankrupt them.

The Fundamentals plan will cost the same family $465/month for ages 31-40, $545/month for ages 41-50 and $725/month for ages 51-63.

- This plan will pay $50 per office visit with a limit of 4 visits per calendar year.
- It will provide negotiated discounts on prescription drugs and will pay $10 toward the cost of generic drugs and $25 toward the cost of brand name drugs with a limit of $750 per calendar year for all prescriptions.
- It will pay $10 per immunization and $10 per allergy shot with a limit of $100 per year for all allergy shots and immunizations.
- It will pay $250 per emergency room visit with a limit of 1 visit per calendar year.
- It will pay $200 per anesthesia event with a limit of 2 events per calendar year.
- It will pay $15 per laboratory test, $300 per CT scan, $450 per MRI scan, $50 per x-ray or ultrasound, $25 per physical therapy, occupational therapy or speech therapy visit for a total of $1,000 per calendar year
- For hospitalizations, it will pay $2,000 per day for illness and $4,000 per day for injury with a maximum of $500,000 per calendar year.

The Enhanced plan will cost the same family $732/month for ages 31-40, $852/month for ages 41-50 and $1,126/month for ages 51-63.

- This plan will pay $75 per office visit with a limit of 4 visits per calendar year.
- It will provide negotiated discounts on prescription drugs and will pay $10 toward the cost of generic drugs and $35 toward the cost of brand name drugs with a limit of $750 per calendar year for all prescriptions.
- It will pay $10 per immunization and $10 per allergy shot with a limit of $100 per year for all allergy shots and immunizations.
- It will pay $400 per emergency room visit with a limit of 1 visit per calendar year.
- It will pay $100 per urgent care visit with a limit of I visit per calendar year
- It will pay $200 per anesthesia event with a limit of 3 events per calendar year.
- It will pay $15 per laboratory test, $300 per CT scan, $450 per MRI scan, $50 per x-ray or ultrasound, $25 per physical therapy, occupational therapy or speech therapy visit for a total of $1,000 per calendar year
- For hospitalizations, it will pay $3,000 per day for illness and $6,000 per day for injury with a maximum of $1,000,000 per calendar year.

The Fundamentals and Enhanced plans offer reasonable coverage for hospitalizations but, in our managed care environment, less and less is being done in a hospital setting. The benefits for any outpatient level of service are appalling in their lack of value. While this type of an approach represents excellent risk mitigation for the insurer, the individual employees do not fare so well. Without the leverage of an employer and the expertise of a benefits manager, individual employees will be left with little choice but to accept policies that leave to

them the burden of shouldering the vast majority of the cost of any medical care that they might incur. In many cases, this will lead to personal bankruptcy. Those bankruptcies, in turn, will deprive medical practices of the income expected from the services that they provided and upon which they depend for their survival. These dynamics will further facilitate acquisition of private practices by managed care owned hospital systems.

These employees, outside of employer-sponsored healthcare, have absolutely no leverage in any disputes that may arise over what little coverage the insurer does provide.

I will provide yet another example from my practice. In December of 2011 one of Minnesota's insurers, Preferred One, provided my office with a notification that they were denying payment for the services provided to their members as not medically necessary. My billing manager called the insurer and was told by one of their executives that, since we were out-of-network, Preferred One would not pay for services provided by my office as they did not want me to treat their members. The members whose payments they denied had out-of-network benefits and had a legal right to services through my office. I have every legal right to evaluate and treat them and, under their contract with Preferred One, the insurer has an obligation to pay for those evaluations and treatments in accordance with the out-of-network provisions of the contract.

In dealing with this situation, I had several options. I could take Preferred One into arbitration but, if you've read this far, you know how well that turned out in the dispute with Blue Cross. I could sue Preferred One for interfering with my right to do business but the legal costs would most likely exceed what I could expect to recoup. However, since I am out-of-network, I have no contractual obligation to write off the fees deemed not medically necessary by Preferred One.

I therefore advised those Preferred One members that their insurer, in breech of their contract, was leaving them liable for payments their insurer was obligated to make. I further advised them to contact the benefits manager for their company and advise that benefits manager of the breech of contract. The benefits manager, armed with this information, not only threatened suit for breech of contract but threatened to pull the company's business permanently from this insurer unless the claims were promptly paid. Preferred One did so within 1-2 weeks.

This leverage is one of the great strengths of employer-sponsored healthcare. Individuals have no such leverage and healthcare providers no longer have the power to advocate effectively for their patients. With the employer removed from the healthcare equation, the insurer's dictate will carry the force of law. There will be no means of recourse. In the process, our healthcare system will be left with the stability of a one legged stool.

I believe that quality healthcare in the United States can be affordable. I also believe that we are being driven toward a healthcare model which guarantees a uniform level of mediocrity to all but those who are in control. I believe we are dangerously close to the imposition of such a system and, if we do not act to alter this course, it may soon be too late. After 30 years of managed care, it is time to recognize that the experiment has failed. It is time to abandon managed care as a healthcare delivery model and return control to employers, consumers and healthcare practitioners.

Chapter Five

Making Healthcare Affordable

The Patient Protection and Affordable Care Act is an oxymoron. The healthcare act does nothing to protect patients. Quite the opposite, the provision for an unelected panel of 15 individuals (the Independent Payment Advisory Board) who wield dictatorial power over what is paid for and how those payments are made under Medicare actually places patients at risk. Rather than making healthcare more affordable, the Affordable Care Act is largely responsible for the 9% increase in health insurance premiums that took place nationally in 2011. This is a horrible piece of legislation and it should be repealed. As detailed in Chapter Two of this book, the socialization of medical care in the United States will never render that care affordable. Even if bureaucratic inefficiency and political corruption could be eliminated, we are still faced with an aging population that is larger than the employed population supporting our healthcare needs.

Like Social Security before it, Medicare was conceived under the premise that the retired population would always be smaller than the employed population. As that premise has proved false, no one is presently counseled to depend on Social Security to meet their financial needs in retirement. We are, in fact, encouraged to invest in IRA, SEP plans and 401k plans to fund the majority of our financial needs in retirement. Why then aren't we similarly encouraged to fund private plans to provide for our healthcare needs in retirement, with Medicare serving only to supplement those needs much as Social Security is used to supplement our 401k distributions?

Likewise, the expansion of managed care in the United States is pointless. Managed care will also never result in affordable healthcare. Unitedhealth Group is the largest private provider of managed care services in the United States with over 75 million members. Its revenue in 2011 was $102 billion[1], making its revenue larger than the gross domestic product of most nations. In fact, according to the International Monetary Fund, only 59 countries in the world have a gross domestic product greater than the annual revenue of Unitedhealth Group[2]. As detailed in Chapter Four, managed care has only succeeded in making its management wealthier than kings. Its very structure ensures that it will continue to drain the U.S. healthcare system of the funds needed to provide quality care to consumers and reasonable compensation to providers of healthcare. After 30 years of failure to make healthcare affordable, managed care should be abolished.

In an effort to make healthcare affordable, Congress passed a Medical Savings Account pilot program in 1996 as part of the Health Insurance Portability and Accountability Act. In this pilot, a Medical Savings Account (MSA) was coupled with a high deductible health plan (HDHP). The HDHP carried a deductible of $2,500 per individual and $5,000 per family. On average, the employer saved 30% when compared to the premium paid for a low deductible health plan (plans with a deductible of $100-250 per individual and $500-1000 per family). The employee of the company offering an HDHP funds his/her MSA via payroll deduction prior to calculation of taxes. The concept behind the pilot was that individuals in charge of a greater percentage of their healthcare dollars would be better consumers, especially as they retained their untaxed MSA funds and could then invest those funds untaxed. As better consumers, these individuals would then help contain healthcare spending and thereby reduce healthcare costs. This approach became widely known as the consumer-driven healthcare movement.

The pilot program was confined to businesses with 50 or fewer employees. Critics of the program included the progressives who claimed that the program would incentivize individuals to forego needed treatment and screening to save money. Concerned with the potential loss of premium revenue, the managed-care insurers echoed the concerns of the political progressives and further expressed concern that these MSA programs would only be used by the healthy, altering the risk pool, and thus drive up premiums for everyone else.

The pilot program, though limited in scope, showed promise. The Bush administration therefore expanded the concept with the establishment of a Health Savings Account (HSA) as part of the Medicare Prescription Drug, Improvement and Modernization Act in 2003. The HSA was required to be coupled with an HDHP but eligibility for these plans was now expanded to all employers. As high deductible health plans increased in popularity among employers, the insurers mitigated their losses by simply increasing the premiums for their plans so that a high deductible plan by 2008 cost as much as a low deductible plan in 2000. This, in turn, acted to mitigate the impact of the consumer-driven healthcare movement as employer costs continued to rise in spite of higher deductibles and a greater share of the cost of healthcare was borne by the employee.

Ultimately, Health Savings Accounts for the majority of employees only served as a means of funding a very large deductible with tax-exempt funds.

The lesson from the consumer-driven healthcare movement is that healthcare costs cannot be controlled by making the consumers of healthcare solely responsible for the cost of healthcare in a market over which they have no control. Healthcare will not be made more affordable by simply handing employees funds by which to purchase their own healthcare. Individual employees lack the negotiating power

of their employers and the value of insurance benefits will inevitably erode as a consequence.

Health Reimbursement Arrangement (HRA) programs were established under section 105 of the Internal Revenue Service code in 2002. HRAs cannot be funded by employee payroll deduction but must be funded solely by the employer. There is no limit on the amount that the employer can contribute to an HRA and the contributions are excluded from the employer's income and consequently are exempt from taxation. Once deposited, however, the funds cannot be removed or used for any purpose other than healthcare without incurring penalties and taxes. HRA funds can be used to pay for medical expenses, dental services, co-pays, deductibles, eye care, etc. HRA funds can be made available to current and former employees (including retirees) as well as spouses and dependents of those employees. HRA funds may be used in combination with a Flexible Spending Account (FSA). Unlike an HSA, an HRA does not have to be coupled with an HDHP or any other healthcare plan. Funds deposited into an HRA by an employer remain the property of the employer unless the employer chooses to vest those funds to the employees. Funds vested to employees can be retained in an account owned by the employee and are not subject to taxation. Unused funds retained by the employer can be rolled into the following year to reduce the employer's contribution in that year and those funds are not subject to taxation. Per section 419 and 419a of the IRS code, however, HRA funds in excess of what is required to cover 13 months of expenses are subject to taxation[3,4].

HRA programs in conjunction with standard health plans and high deductible health plans have fared no better than HSA programs in controlling the cost of healthcare for employers. However, many large, self-funded companies have used stand-alone HRA programs with an insurer hired to simply administer the plan and supply a provider

network and consequent fee schedule to the employer. This approach has been effective in stabilizing healthcare costs for these employers. However, The Patient Protection and Affordable Care Act will make such stand-alone HRA programs illegal in 2014 unless a waiver can be obtained from the Department of Health and Human Services.[5]

There exists no greater evidence of the collusion involved in the formation of a healthcare cartel by the federal and state governments and the managed care insurers than the targeting of stand-alone HRA programs for elimination. Managed care has not been able to derive as much profit from employers with these programs as they have from employers without these programs. Eliminating these programs will force those employers to either purchase more expensive healthcare policies from the insurers or abandon the sponsorship of healthcare and allow their employees to either enter the individual healthcare pool or enroll in the government's program. This is no small matter. The Congressional Budget Office estimates the impact at about 20 million people.

The elimination of stand-alone HRA programs, however, is more than just a gift to the managed care industry. Elimination of stand-alone HRA programs is essential to the survival of managed care, as the road to truly affordable healthcare lies directly through stand-alone HRAs. Though it would require minor modifications of existing tax law (to be discussed in Chapter Seven), virtually any employer could couple an HSA with an HRA and a stop-loss policy to fund healthcare for their employees at a savings of at least 30% over the cost of current healthcare insurance. Again, with modification of existing tax law, the HRA funds retained by the employer after all healthcare expenses have been paid could be invested and accumulate in a tax exempt HRA fund to where the investment income from the fund would be sufficient to pay all future healthcare expenses for those employees in perpetuity without further contribution from the employer.

Here's how the model works. According to the Kaiser Family Foundation and The Health Research & Educational Trust, the average premium in 2011 for family health insurance is $15,073 and the average individual premium is $5,429[6]. Given an employer with 100 employees and a 50-50 mix of families and individuals, the annual premium for health insurance for this employer would be $1,025,100. The employer pays this sum into his HRA. The employer then uses $258,000 of those funds to purchase a stop-loss policy at $20,000 per individual employee and $1,500,000 aggregate. The remaining HRA funds are $767,100 for the year. Each employee with family coverage deposits $6,250 into his/her HSA and each employee with individual coverage deposits $3,100 into his/her HSA. These deposits are made by mandatory payroll deduction over the course of the year. The total HSA funds are $467,500. The total year's funds available for healthcare expenses total $1,234,600, leaving an aggregate risk for the employer of $265,400. These concepts are illustrated in figure 1 and figure 2.

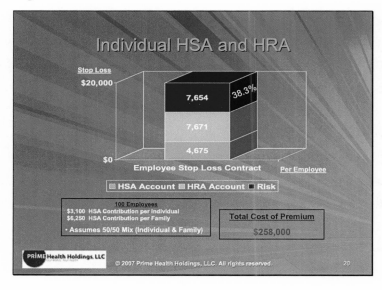

Figure 1

On an individual basis, the risk to the employer is the difference between the stop-loss coverage at $20,000 and the amount deposited per individual into the HSA and HRA funds. This risk is 38.3%, but this risk to the employer represents an overstatement.

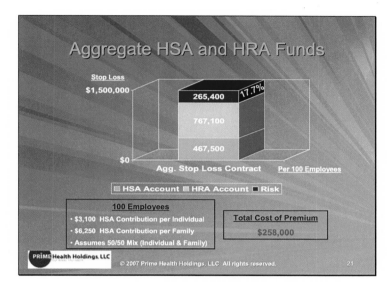

Figure 2

The aggregate risk to the employer is the difference between the stop-loss coverage at $1,500,000 and the total deposits into the HSA and HRA accounts. This risk is a more manageable 17.7% and this is a truer reflection of the employer's actual risk as all loses incurred after triggering the $1,500,000 aggregate are the responsibility of the stop-loss carrier. Also note that even this risk is eliminated after the first year as the $392,100 retained exceeds the $265,400 of aggregate risk. These numbers represent reasonable risk particularly when one considers that insurers will typically raise premiums by as much as 30 % with loss ratios large enough to trigger the stop loss coverage under this plan. In essence, the employer is simply accepting the risk in the

first year versus a premium increase in the second year. As there is no limit as to the amount that the employer is allowed to contribute to his HRA fund, even the risk level in the first year can be mitigated by increasing the contribution and thus can be tailored to meet the needs of each individual employer.

Under this system, HSA funds for the year must be fully utilized before HRA funds can be accessed. Utilization of healthcare service follows a fairly predictable 80/20 rule. 80% of a given group will utilize fewer dollars toward healthcare expenses than are deposited into their HSA. Of the remaining 20%, ½ or 10% of the whole will exceed the funds deposited into their HSA but will not exceed the funds allocated on their behalf in the employers HRA fund. The remaining ½ of that 20%, or another 10% of the whole, will exceed the HSA and HRA allotments and trigger coverage under the stop-loss policy. In other words, 10% of the whole will use more than $4,675 but less than $12,346. The remaining 10% of the whole will use more than $20,000 and trigger the stop-loss coverage. These concepts are illustrated in figure 3 and figure 4.

Figure 3

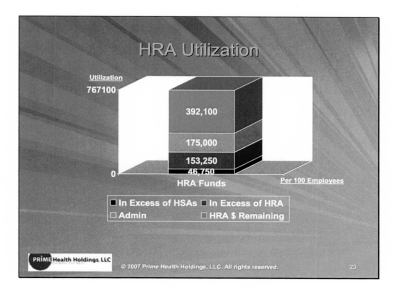

Figure 4

Assuming that the 10% that exceed their HSA funds utilize an equal amount of HRA funds, those employees covered as individuals will utilize $3,100 of HRA funds and those employees with family coverage will utilize $6,250 of HRA funds. Assuming an even mix of individual and family coverage, this group will use a total of $46,750 of HRA funds. The 10% that exceed the HSA funds and trigger the stop-loss policy if also evenly divided between individuals and family will utilize another $153,250 in HRA funds with $68,750 used by families and $84,500 used by individuals. These utilizations totaling $200,000 will reduce the funds remaining in the employer's HRA account to $567,100.

The employer, however, will require the services of a Third Party Administrator (TPA) to not only administer the plan but to also provide access to a physician and hospital network and associated fee schedule.

Without a fee schedule and provider network, no stop-loss carrier will currently participate with an employer. Reasonable TPA fees would be $1,000 per year per employee and $500 per year per dependent.

Assuming a 50-50 mix of individuals and families within this company of 100 employees and assuming an average family of four, the administration fees would cost $2,500 per family per year and $1,000 per individual per year for a total cost of $175,000. Subtracting the cost of administration from the HRA funds remaining after utilization under the 80/20 rule leaves the employer with $392,100 remaining in the HRA. Not coincidentally, this sum is about 1/3 of the health insurance premium that would have been paid as it represents the 25% that the insurer would have deposited into its reserves and a 5% profit. This process is also illustrated in figure 4.

Currently, self-funded employers utilize these retained funds to offset their contribution toward healthcare the following year. However, if section 419 and 419a of the IRS code can be ammended to allow accumulation of these funds untaxed, the employer would be better served to invest these funds and continue funding the HRA with the same amount every year for 16 years. By the end of that time, the HRA fund, assuming an 8% annual return and continued accumulation of $392,100 per year, will have grown to $13,233,454 yielding $1,058,676 annually at an 8% return. The employer's annual contribution of $1,025,100 can now be eliminated entirely as it is replaced by the $1,058,676 annual yield.

To stay on track, employer contributions can be increased in years in which investment returns fall below 8% or utilization is higher than expected. This process can also be accelerated, however, so that this point is reached in as little as 10 years by a combination of increased employer HRA contribution, decreased utilization, and/or higher investment returns.

Once the point is reached at which the employer no longer needs to contribute, the fund will nevertheless continue to accumulate the same $392,100 per year along with the 8% interest so that by year 20 under this plan the HRA fund will have grown to nearly $20,000,000 yielding $1,600,000 annually at an 8% return. Growth should consequently continue to exceed utilization indefinitely. This will allow for healthcare funding for new employees added to the company and may also allow for funding of healthcare for employees after retirement, diminishing the role of Medicare, as discussed in the next chapter.

This is how managed care should function. We do not need to manage the practice of medicine. We have an abundance of highly trained and dedicated professionals to do that and we should trust them to perform their functions. What we do need to manage is the finance of medicine and this approach does just that. If we approach the finance of medical care appropritely, there is no need to ration care. If we manage the finance of medical care appropriately, there is no need to underpay our medical professionals for the highly skilled services that they provide. And unlike the management of medical care, this process is scalable and reproducible. The same principles apply to a company with 100 or 100,000 employees. In fact, the larger the number of employees, the more predictable the 80/20 rule becomes.

This process can also be used on a scale smaller than 100 employees, though the risks are less pedictable the smaller the size. Because of the unpredictability of risk, stop-loss carriers will not consider companies with fewer than 100 employees. However, for those smaller companies willing to accept the risk, a small business healthcare alliance could be organized, with appropriate legal sanction, for the purpose of pooling lives to obtain coverage through a stop-loss carrier. Each company would pay a proportionate share of the stop-loss premium and each company would be responsible for any costs incurred

by its employees beneath the threshhold for stop-loss coverage. Each company would retain the funds in its separate HRA account.

To illustrate this point let us take a company with only 20 employees. With 10 individuals and 10 families and the rates used for the company with 100 employees, the year's insurance premium cost for this company would be $205,020. The 80/20 rule for this company would indicate that only 4 people would exceed the funds in their HSA accounts in the utilization of care that year. One individual and one family would use $3,100 and $6,250 of HRA funds respectively. The utilization of this 10% would total $9,350. The other two individuals would trigger the $20,000 stop-loss policy and use $16,900 for the individual and $13,700 for the family. The HRA utilization for this group would total $30,650. The total utilization of HRA funds under the 80/20 rule for the year would be $40,000. Subtract this from the $205,020 and the funds remaining in the HRA account are $165,020. The proportionate share of the stop-loss policy will reduce this amount by another $51,600 and the cost for the administration of the plan will be $35,000. The company will then retain $78,420 in the HRA account at the end of the year.

This represents the same percentage savings as with the group of 100 employees, as this model is scalable. It would, in fact, require more than 4 more individuals (or 40% of the company) triggering the stop-loss policy to make this plan unprofitable for this company. However, in a small group this can happen and the risk must be understood. On the other hand, however, health insurers do not currently just absorb these losses. Loss ratios of 40% would likely be followed by a 30% increase in premium, costing this company another $61,506 per year while, in the above scenario, the company would have no increase and would fund the same $205,020 the following year. It would, in fact require another 4 individuals triggering the stop-loss policy and bring-

ing the loss ratio to 60% for the company to make it cost-effective to continue the health insurance plan following the increase in premium.

Chapter Six

Winners and Losers

Those who stand to benefit under the system outlined in Chapter Four are the employers paying for healthcare, the employees paying for and receiving healthcare, the medical professionals providing healthcare, Medicare recipients, medical device manufacturers, pharmaceutical companies, all taxpayers, society as a whole, an the economy of our nation. I will discuss the benefits to each of these groups individually.

Employers

The immediate benefit to employers is price stabilization. I intentionally did not factor inflation into the business model discussed in Chapter Four. Doing so would only have added an element of speculation. If fee schedules for health care professionals and hospitals are adjusted annually to mirror the rate of inflation in the economy overall, employers will need to adjust their annual contribution accordingly to keep inflation from eroding the returns on the sums invested. However, these increases should also be offset by the adjustment in prices for the products or services being delivered by these corporations and/ or increases in profits consequent to increases in efficiency. Inflation adjusted, then end result will be the same. After 16 years, the annual return from investment of the HRA fund will replace the employer's annual contribution. To fully appreciate the impact of this, consider that health insurance premium rates have more than trippled in the last 16 years. With this program, the employer's healthcare contribu-

tion for a company with 100 employees falls to zero from $1,050,100 rather than increasing to over $3,000,000 per year.

This brings us to the next major benefit to the employer. Whether it is accomplished in 10 years, 16 years or 20 years, there comes a point at which the employer no longer needs to contribute funds toward the healthcare of the company's employees. The capital which had previously been dedicated to fund this benefit is now available to expand the business. These funds are available to purchase competitors, increase advertising, hire new employees, develop new product or service lines, etc. This increase in liquidity diminishes the need to borrow funds for impotant projects and consequently further improves liquidity by eliminating the finance charges that would otherwise be incurred. This creates a significant competitive advantage over employers who have not adopted this program and over competitors in foreign markets who are unable to avail themselves of this approach to healthcare financing.

The third major benefit to employers is that the funds accumulated in the HRA belong exclusively to the company and thus serve to increase the net worth of the company. If the company is publicly traded, this will serve to increase the share prices for the company. If the company is privately held, it increases the value of the company should it decide to hold an initial public offering. In any sale or acquisition, privately held or publicly held, the value of the HRA is an asset to be factored into the pricing. Certainly, in the case of our company with 100 employees, the company would be worth $20,000,000 less without this program than with this program after a period of 20 years.

As the HRA fund will, at a point around 16 years, continue to grow faster than the expenditures deplete the fund, the company can vest employees whose longevity with the company would warrant vesting. These employees may continue their healthcare coverage through

retirement, with Medicare replacing the stop-loss carrier for these retirees. This added benefit may serve to improve acquisition and retention of key employees and management personnel.

Finally, these companies will benefit from a workforce that is healthier and happier and consequently more productive than a workforce whose healthcare is rationed in the name of increased managed care profits or as the result of the constraints imposed in a government run system of healthcare. As funds grow, these companies can fund and implement meaningful preventive care programs to further enhance the health of its workforce and concurrently decrease healthcare expenditures.

Employees

One of the immediate benefits to employees under this system is stability in their benefits. As the employer will no longer be changing insurance carriers, the need to review what is or is not covered under changing insurance plans is eliminated. Gone also is the interference of managed care entities in the employees' healthcare. Decision making is left to the employee as a healthcare consumer and the professionals consulted for that care.

A second benefit to the company's employees is restoration of the doctor-patient relationship. An insurer may be selected to process claims and provide a network fee schedule, but that insurer no longer has the authority to deny payment for services obtained outside that network. That insurer is a third party claims administrator under this system and has no contractual right to interfere with care. Consequently, no employee need change his or her physician based on network participation so long as that physician is willing to accept the payment allowed under that fee schedule. This should pose little difficulty as network

fee schedules will become increasingly uniform as the insurers are no longer able to extract a profit from reducing the income due healthcare professionals. The claims administrator's income is derived from its contract with the employer. While a given insurer might claim to be able to decrease the employer's healthcare costs and thereby increase the employer's HRA fund more quickly by paying the professionals in their network less, this system allows little motivation to do so. A 10% reduction in fee schedule would only yield a 1% retention in HRA funds. If that 1% were divided between the employer and the claims administrator, each would only receive 0.5%. On the other hand, that insurer will have to contend with growing discontent within its network and will derive too little profit to make that wothwhile, especially if that discontent leads to a decrease in participation and a consequently smaller, less marketable network. To prevent abuse of this system by healthcare entities outside of the network used, the employee will be responsible for payment of fees in excess of what is allowed under the fee schedule as part of the employee's contract with the employer.

The third benefit to the employee is financial. The annual medical expense for each employee is fixed at his/her annual HSA contribution, except for those foolish enough to use out of network entities intent on gouging them. While this may seem like a recipe for overutilization, it is not. Like the employer, each employee has a motivation to accumulate HSA funds in his/her account to a point at which those funds are large enough to allow the earnings to replace the payroll deduction in providing his/her annual HSA contribution. The average healthy individual employee contributing $3,100 per year to his/her HSA and utlizing $1,100 per year will accumulate $60,371 in 15 years at an 8% rate of return. The annual earnings at 8% on that $60,371 will now eliminate his/her payroll deduction for HSA funding even if the individual funding requirement has risen to $4,600 per year during

those 15 years. This individual may wish to continue funding his/her HSA, especially if the program is to be continued in retirement, but would no longer have a requirement to do so.

If an employer has chosen or is required to extend healthcare coverage to retirees, the accumulation of HSA funds over 30 years of employment can allow the earnings from those funds to cover the individual annual contribution to healthcare costs during retirement without depleting either the HSA or retirement accounts established to cover other living expenses during retirement. While this can be done in combination with Medicare as it exists today, the funding reality for Medicare suggests that this will not be an option. Thirty years from now, Medicare will most likely not exist in its present form. The accumulation of HSA funds and continued access to the employer's health plan during retirement may consequently be the only protection remaining to prevent depletion of all of the employee's assests by age-related illness. This may represent the most significant benefit of all that this program offers to the employee.

Healthcare Professionals

The most immediate benefit to healthcare professionals under this system is freedom from the unnecssary and unwelcome intrusion of managed care in medical decision making. Restoration of the doctor-patient relationship is at the core of this model.

Medical decision making will again be the exclusive domain of the doctor and his/her patient. Healthcare professionals will no longer be referred to by the demeaning moniker "provider." We are all skilled professionals, many highly trained. We are doctors, nurses, physical therapists, pharmacists, etc. Each of us has a unique set of talents and skill sets. We are not interchangeable.

This system will again begin to reward healthcare professionals for the time invested in acquiring their skills and for the effort and dedication brought to the practice of medicine. As claims processors no longer derive any significant benefit from diminishing the reimbursement of healthcare professionals, that reimbursement will rise as competition in the market leads to more claims processors with a need to develop their own networks and therefore offering more generous fee schedules to attract participants into those networks. As an example, fee schedules could increase 10% without impacting the employer's healthcare contribution and/or HRA fund retention more than 1%. This is consequent to the plan design. The increase in fee schedule will have no impact on the employer for the 10% who trigger the stop-loss policy. The increase will have no impact on the employer for the 80% of employees who never utilize more than their HSA contribution. The impact will be felt only on the 10% of employees who utilize more than their HSA funds cover but do not use enough to trigger the stop-loss policy. 10% of 10% results in a 1% cost to the employer. This should occur early in the course of adoption of this system. Furthermore, fee schedules can be adjusted for inflation without adversely impacting the system as the employer's HRA contribution and the employees' HSA contributions are similarly pegged to inflation. This will prevent reimbursements from lagging behind inflation as they have for the last decade or two. Over time, especially as the employers' HRA funds have grown to where they are self-sustaining, free market dynamics can be restored and fee schedules can be eliminated.

Restoring free market dynamics can occur because the HRA funds owned by the employer cannot be used for any purpose other than healthcare. These funds cannot be drained to pay higher salaries for management within the company. They cannot be used for bonuses.

They cannot be used to fund elaborate corporate parties. They cannot be used to increase market share through expensive advertising campaigns. They cannot be used to reward investors. Unlike the funds flowing into the hands of managed care, these funds remain in the healthcare system. If these funds are used for anything other than healthcare, the employer is subject to taxes on those funds along with substantial penalties. Therefore, once the fund has become self-sustaining, there exists little motivation on the part of the employer to restrict his employees' access to healthcare or to unfairly limit the earnings of healthcare providers.

Medicare Recipients

Restoration of the doctor-patient relationship and freedom from the intrusion of managed care is a benefit to all consumers of healthcare but may benefit Midicare recipients most of all. Elimination of the managed care profits which have been driving medical inflation for the last 20-30 years will serve to make healthcare more affordable in all systems, including Medicare. Elimination of the Independent Payment Advisory Board as no longer necessary in addressing Medicare's escalating costs will pevent widespread healthcare rationing among our seniors. In 20-30 years, as this system begins to cover individuals retiring from the workplace, the cost over-runs projected by the Congressional Budget Office will dissipate and the funds available through Medicare should be able to meet the needs of a proportionately smaller population of individuals who did not manage to acquire benefits under their employer for use in retirement.

Medical Device Manufacturers

The Patient Protection and Affordable Care Act provides for a 2.3% exise tax to be paid by manufacturers to the federal government on the sale of medical devices starting in January of 2014. In a free market, these manufacturers would adjust the price of their products to reflect the tax. Healthcare in the United States, however, no longer operates in a free market. The same federal government imposing this exice tax on these manufacturers also sets the rate under Medicare that will be paid for their devices. The private health insurers do the same. Consequently, doctors and hospitals purchasing these medical devices are in no position to pay more for the products if they are unable to bill and receive more from the federal government or private insurers for the use of these products.

This tax consequently must be borne either by reducing the profits of the medical device manufacturers or by further reducing the already meager profits of doctors and hospitals operating within this system. If the device manufacturer is unable or unwilling to absorb the cost of this tax and the doctors and hospitals are likewise unwilling or unable, patients in need of these devices will suffer. Items involved would include pacemakers, heart monitors, prosthetic devices for hip and knee replacements, hardware for spine surgery, stents for heart surgery and intrathecal pain pumps to name just a few. A number of device manufacturers have already warned that the tax would exceed their profits and drive them into insolvency.

Implementation of this tax on medical device manufacturers will have a chilling effect on research and development. These companies will become unwilling to invest in the development of new products if profit margins are too low to justify the investment. Such stagnation is also not in the best interest of healthcare consumers.

Repealing the Patient Protection and Affordable Care Act and

replacing it with the approach to healthcare financing outlined in Chapter Four would resolve these problems. Healthcare consumers would retain access to needed medical devices and continued research would ensure improvement in the devices available for use in a wide variety of medical conditions. Our medical device manufacturers would be free to operate in a dynamic market that would reward innovation and quality manufacturing while competion and manufacturing efficiencies serve to control cost.

Pharmaceutical Companies

The Patient Protection and Affordable Care Act also imposes a new excise tax on the sale of brand name prescription medications. Unlike the tax on medical device manufacturers, this tax is complicated and convoluted. Orphan drugs used only for orphan conditions are exempt from the tax. Generic drugs are also excluded from the tax except for quasi-generic drugs approved under Section 505(b)(2) of the Federal Food Drug and Cosmetic Act.

The law does not establish reporting requirements for the pharmaceutical companies. Rather, the tax is determined by the Secretary of the Treasury from data provided by the Department of Health and Human Services, the Veterans' Administration, the Department of Defense and "any other source of information available to the Secretary of the Treasury." In essence, unlike any other tax levied, the Secretary of the Treasury determines the amount of the tax owed, not the accountants for the entity being taxed.

The amount of the tax owed is based upon the market share of brand name drugs held by each individual company and the percentage is tiered based on market share.

A company with $5 million in annual brand name sales or less pays	0%
A company with more than $5 million but not more than $125 million pays	10%
A company with more than $125 million but not more than $225 million pays	40%
A company with more than $225 million but not more than $400 million pays	75%
A company with more than $400 million pays	100%

These percentages are used to calculate the "sales taken into account." Thus, for a company with $300 million in brand name sales, the "sales taken into account" would be 75% of $300 million or $225 million.

The "sales taken into account" is now divided by to total sales of brand name drugs to determine the percentage tax owed by the company. If we assume the total brand name sales are $30 billion then the percentage owed by this company would be $225,000,000 divided by $30,000,000,000 or 0.75%. This is the company's "ratio."

To determine the tax owed by the company that ratio is applied to the "applicable amount." This amount is presently set to grow annually as follows:

2019	$2.5 billion
2020	$2.8 billion
2021	$2.8 billion
2022	$3 billion
2023	$3 billion
2024	$3 billion
2025	$4 billion
2026	$4.1 billion

Thus, in the case above, the company with $300 million in brand name sales would incur a tax of 0.0075 x $2,500,000,000 or $18,750,000, representing 6.25% of annual sales. Also, if this company's ratio remains the same, its tax will grow to 0.0075 x $4 billion or $30 million in 2017.

Unlike physician, hospital and medical equipment charges, the prices for brand name prescription medications are not set by federal or state governments and they are not set by private insurance companies. The pharmaceutical companies do have the ability to set the price for any new drug that they bring to market. Consequently, it is not likely that the pharmaceutical companies will simply absorb this new tax and reduce their profits. The tax will be factored into the price of each new drug. This tax is consequently inflationary in its impact. These increased pharmaceutical costs will be reflected in the insurance premiums paid by employers and individuals. These tax revenues from the pharmaceutical companies do, in other words, simply translate into an indirect tax levied on employers and consumers of healthcare through higher premiums and/or higher prescription co-pays. Those who are receiving their healthcare through private programs will pay more in order to provide the pharmaceutical companies with revenue to pay the taxes to subsidize the public programs—billions of dollars more. As pharmaceutical costs for public programs will also rise, however, these taxes on pharmaceutical companies will additionally spur an increase in direct taxation on all workers to cover the increased cost of pharmaceuticals. The bottom line is that nothing has ever been made cheaper by taxing it more. This is not a valid funding vehicle for "Obamacare." It is a shell game, pure and simple.

While the taxes imposed on the pharmaceutical companies can, and most likely will, be passed on to consumers, the increased cost of new pharmaceuticals will make it harder for these companies to

penetrate markets, recoup their investment in the development of their drugs and then generate a profit. Federal and state governments along with private insurers have been aggressive in their mandate for the use of generics over brand name drugs in virtually all circumstances. It is likely that they will further strengthen these mandates. These barriers to bringing a new drug to market only serve to further increase the cost of any new drug. If, ultimately, those barriers cannot be penetrated and the market for a new drug shrinks, this only further increases the cost of that new drug.

It would be more beneficial for pharmaceutical companies to have lower barriers to entry for new drugs. Lower barriers to entry reduce marketing and sales costs. Lower barriers to entry can increase the market size and sales volume. Decreased cost and increased volume allow for lower prices. Lower prices for newer, more effective medications, medications with fewer serious side-effects or harmful drug interactions would also be more beneficial for consumers. We need less, not more, regulation.

Pharmaceutical companies would benefit from the approach to healthcare finance outlined in Chapter Four by eliminating artificial and needless barriers to market entry for new drugs. They would benefit by gaining access to free market dynamics which will enable them to provide superior products at affordable prices.

Taxpayers

Without adoption of the healthcare financing approach outlined in Chapter Four, all taxpayers will inevitably see an increase in marginal tax rates to fund an endless expansion in healthcare mandates; mandates which do little to improve the quality of our healthcare but greatly increase the cost with no expansion in benefits. Mandates such

as the requirement for electronic medical records and the development of Accountable Care Organizations add layers and layers of cost but do little to nothing to actually increase the quality of care and certainly to nothing to increase the benefits provided for the cost incurred. Expansion of benefits to larger and larger segments of the population will further strain the ability of the government to provide those benefits without expanding its tax base.

The expansion of this tax base may start as a higher tax bracket for the wealthy, but history has shown that tax increases always extend to and fall hardest on the middle class. Why? Because the middle class is larger than the upper class. A 10% increase on 50% of the population will yield more revenue than a 50% increase on 1% of the population and that increase in revenue will be necessary. Fortune 500 companies have already examined the impact of the Affordable Care Act on their profits and have concluded that it would be less expensive to force their employees onto state subsidized insurance exchanges in 2014 and pay the pay the penalty for not providing health insurance than to continue providing healthcare coverage under the mandates imposed by the Affordable Care Act. These companies will save as much as $400 billion over ten years by ending their healthcare subsidies and paying the penalties to the federal government. However, this will immediately add approximately 20 million more enrollees to the government subsidized insurance exchanges leading to the need for increased tax revenues to cover the additional cost. This process will cascade. As small and medium size businesses pay more in taxes to subsidize a government sponsored healthcare program and higher premiums to private insurers as a result of the excise tax imposed on those insurers in 2014, they will become increasingly unwilling and/ or unable to fund their existing private healthcare. Why pay for two programs when you can only derive benefit from one? This will drive

millions more onto the government sponsored system and further spike the need to increase tax revenues to fund the expanding roster. Any remnant of private insurance still in existence will then surely die in 2018 when the 40% excise tax on "Cadillac Plans" takes effect as any remaining private plans would surely be characterized as "Cadillac Plans."

These increases in taxes are already slated to take place. Effective January 1, 2013 The Patient Protection and Affordable Care Act imposes a 0.9% tax on individuals who earn $200,000 per year or more from self-employment or wages. The threshold for this tax increases to $250,000 for married couples filing jointly but drops to $125,000 for married couples filing separate returns. In addition, there is a 3.8% tax on the lesser of investment income or the amount by which income exceeds the thresholds noted above. Thus, a married individual making $150,000 per year filing separately can see his overall tax increase by 0.9% and also pay an additional 3.8% on the $25,000 earned above the $125,000 threshold. This individual is not part of the rich 1%; this individual is solidly middle class. And this process has only just begun.

As shown in Chapter Two, withholding rates for Medicare and Social Security will also need to increase drastically if these programs are to remain solvent. The Congressional Budget Office currently estimates the Medicare tax shortfall at 3.88% of taxable payroll. Addressing that shortfall would require increasing the Medicare tax to 5.33% of payroll and 10.66% of the income from self-employment if anticipated expenditures do not change.

Repealing the Patient Protection and Affordable Care Act and adopting the finance structure for healthcare outlined in Chapter Four will prevent the need for these tax increases. All taxpayers would benefit from lower tax rates and access to higher quality, more affordable healthcare.

Society as a Whole

Contrary to the demonization of conservatives by the progressive liberals within our country, conservatives are not insensitive to the needs of the poor. Conservatives, along with liberals, donate to charities. Conservatives, along with their liberal counterparts, recognize that social programs are necessary to provide for basic needs of individuals who, through no fault of their own, are too impoverished to meet those needs. There does exist a divide between conservatives and liberals as to what constitutes a basic need. Our country's liberals, for example, would and do argue that ownership of a functioning cell phone by every individual, child or adult, is a basic need and should be funded by our government. Many conservatives would and do disagree. There is also disagreement as to who is poor through no fault of their own as well as the very definition of poor.

Ironically, however, it is the actions of these progressive liberals, who so loudly decry the heartlessness of conservatives, that are swelling the ranks of the poor and reducing the standard of living for all Americans. The Community Reinvestment Act, for example, was intended to extend the benefit of home ownership to a larger segment of the American population. Banks were pressured by the federal government to provide loans to individuals whose incomes were too low to qualify under traditional lending standards. These subprime loans led to a boom in the housing market and an escalation in home values through the 1990s and the first decade of 2000 until the housing bubble burst in 2008. High foreclosure rates resulting from these faulty lending practices have reduced home values and the net worth of all Americans. Likewise,the endless extension of unemployment benefits to those who lost their jobs in the recession that began in 2008 has perpetuated unemployment. The government does not fund unemployment benefits.

Employers fund unemployment benefits through unemployment taxes levied exclusively on employers. Those taxes have risen 400-600% since 2007 as a consequence of these extensions of unemployment benefits and are serving to inhibit hiring by employers. As the tax is calculated as a percentage of payroll, the higher the payroll—the higher the tax.

No government can provide all things to all people. The effort to do so only dilutes what is available to any individual. This basic truth applies as much to healthcare as it does to any other product or service. Expanding the government's role to provide healthcare to all Americans will inevitably reduce the quality of care available to all Americans. That this will impact the rich and the middle class does not lessen its impact on the poor. For the poor to retain access to high quality healthcare, it is necessary to limit the scope of governmental involvement so that the government's resources can be devoted to the poor. Repealing the Patient Protection and Affordable Care Act and replacing it with a finacial structure for healthcare as outlined in Chapter Four will allow our country to retain social programs for the poor that guarantee their continued access to high quality medical care.

Our Nation's Economy

The health of any nation's economy can be gauged by its private sector growth. Private sector jobs represent the lifeblood of a capitalist economy, as this sector supports the public sector through its taxes. Yes, individuals employed in the public sector also pay taxes but I have yet to meet anyone in the public sector who pays more in taxes than he/she receives in income. Public sector income therefore has to be derived from private sector income.

Healthcare represents 18% of our nation's economy. The Patient Protection and Affordable Care Act will, for all of the reasons outlined above, result in the complete socialization of healthcare. Socializing 18% of our nation's economy cannot be healthy in a capitalist economy. A higher tax burden will inevitably need to be borne by a smaller private sector. This will only serve to limit growth in the private sector at best. More likely, it will increase unemployment and perpetuate economic stagnation. It will lead to increased deficit spending to fund public programs for which there are insufficient tax dollars from the private sector, increasing our national debt. As the interest payments on that debt take on a larger share of the tax revenues collected, funds available for those social programs will shrink and result in the need to ration the services provided.

Taxing the healthcare device manufacturers beyond the point of profitability will remove manufacturers from the marketplace as companies fail, depriving healthcare of the innovations that they would have contributed and producing shortages which will contribute to rationing while paradoxicaly driving up cost. Similarly, taxing pharmaceutical companies will only lead to decreases in innovation and increases in what we do pay for those new drugs that do manage to come to market.

There is a better way. The approach outlined in Chapter Four will preserve employer-based healthcare and concurrently increase the value of the companies providing healthcare to their employees. Freed from the need to fund healthcare costs after a 16 year term, these companies can invest the revnue previously spent on healthcare in expanding their businesses and increasing employee compensation. Far from economic stagnation and increasing unemployment, this will serve to fuel economic growth and concommitant employment. This will expand rather than shrink the private sector. The expansion in the

private sector job growth will allow for better compensation for all employees which will, in turn, then generate larger tax revenues with which to shrink the national debt.

Increasing corporate and individual incomes will also result in increased investment in the stock market, increasing corporate capital with which to further fuel corporate and economic expansion. As individual investments through HSA, IRA, 401k and other retirement plans flourish, individuals will be less dependent on government for support, diminishing the scope of social programs. As HRA funds begin to cover medical expenses in retirement, Medicare will fund a smaller subset of retirees and higher payroll taxes will no longer be necessary to meet Medicare's obligations.

Losers

As in any capitalist system, in order for one group to succeed another must fail; for one group to win another must lose. Under the system outlined in Chapter Four, the groups which win are the employers, their employees, healthcare professionals, medical device manufacturers, pharmaceutical companies and all taxpayers. The group which has benefitted under our current system of healthcare at the expense of the afore-mentioned groups is managed care. The financial benefits to managed care companies have, in fact, been enormous and the shift in funding required to salvage our healthcare system will produce equally enormous losses for managed care—losses so extreme that managed care will not be able to continue its existence. The loser in this system is managed care.

This is not all bad. Managed care has had twenty years in which to make healthcare affordable and prove its worth. Managed care has failed in that task. Healthcare is much less affordable now than when

the reins were turned over to managed care twenty years ago. It is time for managed care to pay the price for that failure. Nor should anyone mourn the passing of managed care. In a strong economy, poor products give way to better products on an everyday basis. No one mourns the loss of vinyl records. Compact discs allow for better sound quality and larger storage space for those songs. No one mourns the passing of video cassettes in favor of high definition DVDs. It is time for managed care to go the way of vinyl records and video cassettes. It is time for progress.

Chapter Seven

A Call to Action

This book is about transforming the way that we finance healthcare in the United States. Yet, in so many ways it is so much more. Our current healthcare systems are more or less variations of social welfare. As such, there are inherent limitations on the resources that can be allocated to and spent on healthcare. Utilization of these resources represents a drain on our national and corporate economies. While such limitations are inescapable in socialist models, they do not have to exist in capitalist models. This difference is consequent to the basic principle that capital, if properly handled, expands. This principle is the basis by which capitalist economies have been able to offer a plurality of choices in every walk of life, and offer those choices in a variety of price ranges to suit individuals from every walk of life. It is the basis by which capitalist economies have provided a successively higher standard of living to each successive generation within those economies.

In transforming the way in which we finance healthcare, we also, therefore, begin a transformation from an increasingly socialist state to a country whose roots are again firmly capitalist. We are, after all, transforming 18% of our nation's economy. In doing so, we can again begin to view the world from the perspective of abundance rather than one of scarcity. America can again become a country whose future is viewed as brighter than its past. We can again become a country where anyone with the drive to succeed can succeed, and succeed in any occupation that he/she chooses. We can again become a nation where those who work to succeed can retain the profits of their success, a nation where those profits are no longer envied but instead serve as

motivation for others to emulate those successes. Transforming the finance of healthcare, therefore, is only the beginning. The effects of this transformation will be felt in every aspect of life and will improve that life for every American.

However, none of this can or will take place without a beginning and every beginning requires a first step. This first step dictates a departure from the path toward socialism and a return to the path toward capitalism. For healthcare, therefore, the first step is to repeal the Patient Protection and Affordable Care Act. The Affordable Care Act is the embodiment of socialism. It represents a movement to reduce healthcare to a uniform level of mediocrity. Why, otherwise, is it necessary to place a 40% excise tax on "Cadillac health plans"? Is it somehow immoral for an employer to offer his/her employees better heath coverage? Do we therefore need to punish companies that do so?

No, it is simply that socialism requires uniformity. No one, regardless of talent or expenditure of effort, deserves to have more than anyone else under a socialist system. Class envy is consequently the principle tool of socialism. Instead of encouraging individuals to become part of the 1%, socialists work to redistribute the wealth of the 1%. Income inequality is viewed as undemocratic and must be erased under a socialist system. However, in erasing income inequality, in destroying class distinctions, socialists also destroy the motivation, ambition and innovation that once made America the envy of the world. In doing so, socialists have contributed to America's decline and have created a country in which our past is brighter than our future. The Affordable Care Act must be repealed. We must return to a path in which our country's future is far brighter than its past. If you agree, go to my website at www.politicsandhealthcare.com and click on the button "Repeal ObamaCare" and add your name to the petition. Ask everyone you know to do the same. I will forward the petition

with the list of names monthly to each of the senators from each state until the legislation is repealed.

The repeal of the Affordable Healthcare Act is also necessary for the approach to healthcare finance outlined in Chapter Four to take place. The Affordable Healthcare Act makes stand-alone HRAs illegal as of 2014. This would proscribe implementation of the healthcare finance model outlined in Chapter Four and doom the country to implementation of a socialist model in perpetuity.

Beyond repealing the Affordable Healthcare Act, however, it is also necessary to amend sections 419 and 419a of the Internal Revenue Service code. These sections of the IRS code govern the treatment of employer-sponsored benefit plans from a tax perspective. While section 105 of the IRS code allows employers unlimited tax-exempt contribution into an HRA, sections 419 and 419a provide for taxation of those funds if they exceed what is required to cover 13 months of healthcare expenses. Sections 419 and 419a consequently prevent the accumulation of untaxed funds in an HRA by which an employer could eventually fund all of its healthcare costs from the investment revenue generated by that HRA. For the healthcare finance model in Chapter Four to work, sections 419 and 419a of the IRS code must be amended to allow for tax-exempt treatment of all funds contributed by an employer into an HRA so long as those funds either remain in the HRA or are utilized for healthcare expenses.

This proposed amendment to sections 419 and 419a of the IRS code would be tax neutral in its consequences. Employers who purchase health insurance on behalf of their employees deduct those premiums as a business expense. If the funds deposited into an HRA are equal to what would have been paid for a health insurance premium, the country is losing no tax revenues simply because the funds in excess of HRA utilization in any given year are retained in the HRA. The

only difference between the two models is that the untaxed funds used to purchase health insurance under the current model are placed into the untaxed reserves of the insurer while under the proposed model those same funds are placed into the untaxed HRA of the employer.

In spite of the tax neutral status of the proposed amendment to sections 419 and 419a of the IRS code and the benefits that would follow implementation of the healthcare finance model proposed in Chapter Four, I anticipate strong resistance to amending the IRS code. This resistance will predictably come from not only the insurance industry lobby but also from those members of government whose agenda is to socialize medicine.

A strong grass-roots movement will therefore be needed to push for change. If you agree with the approach that I have advocated, please go to my website at www.politicsandhealthcare.com and click on the button "amend section 419 and 419a" and add your name to the petition. Ask everyone you know to do the same. I will forward the petition with the list of names monthly to each of the senators from each state until the amendment is secured.

One final clarification in the tax law must also be made in order for the finance model proposed in Chapter Four to be implemented. Current law requires HSA accounts to be coupled with a qualified high deductible health plan (HDHP). The IRS has to date recognized high deductible insurance policies as HDHPs compatible with an HSA. While the IRS could recognize an employer program as outlined in Chapter Four (i.e. an HRA coupled with a stop loss policy accessed only after a large deductible has been met) as an HDHP, there is no assurance that they would necessarily do so. The IRS could take the narrow view that an HDHP must be an insurance plan. It would therefore be prudent to obtain a ruling from the IRS in this regard before attempting to implement this plan. This, however, should be relatively

easy in comparison to the effort that will need to be expended to change IRS code 419 and 419a.

We, as citizens of the greatest republic the world has ever known, have the ability and the right to reclaim control over our healthcare and, in the process, improve the financial future for ourselves and our country. I implore you to add your voice today to this movement. Go to www.politicsandhealthcare.com and add your name to the petitions listed there. Sign up to follow our progress as we post developments on the website's blog. Together, we can do this.

References

Chapter One

1. Marmor, Theodore R. *The Politics of Medicare*, second edition. Aldine de Gruyter, 2000.
2. Demographics.Berkley.edu
3. Information Please@database@2011 Pearson Education, Inc.

Chapter Two

1. Patient Protection and Affordable Care Act, pages 317-337.
2. Turner, Grace-Marie, "The Real Tragedy Of ObamaCare Has Yet To Be Felt By The Poor" Forbes OP/ED 08/21/2012.
3. Patient Protection and Affordable Care Act, pages 2000-2003 and Reconciliation Act pages 87-93.
4. Patient Protection and Affordable Care Act, pages 345-346.
5. Patient Protection and Affordable Care Act, pages 1,986-1,993.
6. Patient Protection and Affordable Care Act, pages 1,941-1,956.
7. Patient Protection and Affordable Care Act, pages 1,971-1980.
8. Patient Protection and Affordable Care Act, pages 1,980-1,986.
9. Patient Protection and Affordable Care Act, pages 1,994-1,995.
10. Patient Protection and Affordable Care Act, pages 2,388-2,389.
11. Patient Protection and Affordable Care Act, pages 1,957-1,959.
12. Patient Protection and Affordable Care Act, page 1,994.
13. Patient Protection and Affordable Care Act, page 1,959.
14. Patient Protection and Affordable Care Act, pages 1,995-2000.
15. www.money.msn.com/investing/americas-highest-paid-ceos 10/20/2011
16. Patient Protection and Affordable Care Act, page 2004.
17. Patient Protection and Affordable Care Act, pages 2005-2006.
18. Patient Protection and Affordable Care Act, pages 1,961-1,971.
19. aflcio.org/Corporate-Watch/CEO-Pay-and-the-99/CEO-to-Worker-Pay-Gap 12/31/2012
20. ips-dc.org/reports/executive_excess_2010 12/31/2012
21. The Physicians Foundation "A Survey of America's Physicians" September, 2012.

22. Anderson, Jeffrey H, "CBO: Obamacare to Cost $1.930 Trillion, Leave 30 Million Uninsured," The Weekly Standard July 27, 2012.

23. jeffduncan.house.gov/full-list-obamacare-tax-hikes 11/10/2012.

Chapter Three

1. Marmor, Theodore R. *The Politics of Medicare*, second edition. Aldine de Gruyter, 2000, pages 98-101.

2. Herzlinger, Regina *Who Killed Health Care*, McGraw-Hill 2007, pages 116-120.

3. Marmor, Theodore R. *The Politics of Medicare*, second edition. Aldine de Gruyter, 2000, pages 104-119.

4. Marmor, Theodore R. *The Politics of Medicare*, second edition. Aldine de Gruyter, 2000, page 135.

5. Marmor, Theodore R. *The Politics of Medicare*, second edition. Aldine de Gruyter, 2000, pages 141-150.

6. Congressional Budget Office, *Economic and Budget Issue Brief,* "The Sustainable Growth Rate Formula for Setting Medicare's Physician Payment Rates," September 6, 2006, pages 1-8.

7. Clemens, M. Kent, Office of the Actuary, Centers for Medicare & Medicaid Services, "Estimated Sustainable Growth Rate and Conversion Factor, For Medicare Payments to Physicians in 2012." March, 2011.

8. Kunin, Svetlana "Perspectives of a Russian Immigrant" Investors Business Daily Editorial 12/19/2011.

9. Center for Medicare Advocacy, Inc., "Summary of Medicare Act of 2003, Copyright © 2004.

10. Park, Edwin, "Lower-Than-Expected Medicare Drug Costs Reflect Decline in Overall Drug Spending and Lower Enrollment, Not Private Plans. Evidence Shows Reliance on Private Insurers Actually Raised Medicare Costs" Center on Budget and Policy Priorities, May 6, 2011.

11. www.aha.org/advocacy-issues/rac/index.shtml. "Recovery Audit Contractor (RAC) Program. American Hospital Association, 12/14/2011.

12. Trapp, Doug, "Medicare RACs to Conduct Prepayment Reviews for Doctors, Hospitals," American Medical News,

amednews.com, posted November 28, 2011.

13. Potetz, Lisa; Cubanski, Juliette; Neuman, Tricia "Medicare Spending and Financing: A Primer," Health Policy Alternatives, Inc. and The Henry J Kaiser Family Foundation, February 2011, page 9.

14. Geithner, Timothy *Secretary of the Treasury and Managing Trustee of the Trust Funds*; Solis, Hilda L. *Secretary of Labor, and Trustee*; Sebelius, Kathleen *Secretary of Health and Human Services, and Trustee*; Astrue, Michael J. *Commissioner of Social Security, and Trustee*; Frizzera, Charlene M. *Acting Administrator of the Centers for Medicare & Medicaid Services, and Secretary, Boards of Trustees*, "2009 Annual Report of The Boards of Trustees of The Federal Hospital Insurance and Federal Supplementary Medical Insurance Trust Funds." Page 29.

15. Geithner, Timothy *Secretary of the Treasury and Managing Trustee of the Trust Funds*; Solis, Hilda L. *Secretary of Labor, and Trustee*; Sebelius, Kathleen *Secretary of Health and Human Services, and Trustee*; Astrue, Michael J. *Commissioner of Social Security, and Trustee*; Frizzera, Charlene M. *Acting Administrator of the Centers for Medicare & Medicaid Services, and Secretary, Boards of Trustees*, "2009 Annual Report of The Boards of Trustees of The Federal Hospital Insurance and Federal Supplementary Medical Insurance Trust Funds." Page 202.

16. Patient Protection and Affordable Care Act, pages 2000-2003 and Reconciliation Act pages 87-93.

17. Patient Protection and Affordable Care Act, pages 1,986-1,993.

18. Patient Protection and Affordable Care Act, pages 1,941-1,956.

19. Potetz, Lisa; Cubanski, Juliette; Neuman, Tricia "Medicare Spending and Financing: A Primer," Health Policy Alternatives, Inc. and The Henry J Kaiser Family Foundation, February 2011, page 16.

20. Geithner, Timothy *Secretary of the Treasury and Managing Trustee of the Trust Funds*; Solis, Hilda L. *Secretary of Labor, and Trustee*; Sebelius, Kathleen *Secretary of Health and Human Services, and Trustee;* Astrue, Michael J. *Commissioner of Social Security, and Trustee;* Blahous III, Charles P. *Public Trustee*; Reischauer, Robert D., *Public Trustee;*

Berwick, M.D., Donald M. *Administrator of the Centers for Medicare & Medicaid Services, and Secretary, Boards of Trustees.* "2011 Annual Report of The Boards of Trustees of The Federal Hospital Insurance and Federal Supplementary Medical Insurance Trust Funds." Pages 39-40.

21. Internal Revenue Service, Statistics of Income, "Individual Income Tax Rates and Shares, 2009"
22. Sonier, Julie "MinnesotaCare: Key Trends & Challenges," *Rural Minnesota Journal* Vol 2, Issue 1 pages 37-52.
23. Minnesota Department of Health "Minnesota Health Care Spending and Projections, 2009" June 2011 pages 1-17.
24. Schill, Kathy "Health Care Access Fund (HCAF) Transfer Issues" Fiscal Analysis Department, Minnesota House of Representatives June 9, 2004 (revised 2007).
25. www.house.leg.state.mn.us/members/pressreleasels85. asp?district=22A&pressid 1/2/2012.
26. Minnesota Department of Revenue. "Summary of Minnesota Health Care Revenues" FY 2010-11.

Chapter Four

1. www.money.msn.com/investing/americas-highest-paid-ceos 10/20/2011
2. Pugh, Tony "Health Insurance Costs Rise Sharply" Star Tribune September 28, 2011. Pages A1 and A5.
3. Daily Graphs Online © William O'Neill + Co., Inc.
4. BDC Advisors "Trends in Physician-Hospital Integration," June 2010.
5. Goodman, John C. *heartlander* "Why Medicare's Pilot Programs Failed," April 10, 2012.

Chapter Five

1. www.etrade.wallst.com/v1/stocks/earnings/earnings. asp?view=revenue 4/21/2012.
2. http://en.wkipedia.org/wiki/List_of_countries_by_GDP_ (nominal) 4/21/2012.
3. Internal Revenue Code: Sec. 419. Treatment of funded welfare benefit plans
4. Internal Revenue Code: Sec. 419A. Qualified Asset Account; limitation on additions to account.
5. "Stand-Alone HRA May Violate the Health Care Reform Law Without an HHS Waiver" The Jaeckle Alert, November 2010.
6. 6. Pugh, Tony "Health Insurance Costs Rise Sharply" Star Tribune September 28, 2011. Pages A1 and A5.